A–Z
OF
BURY
ST EDMUNDS

PLACES - PEOPLE - HISTORY

Martyn Taylor

AMBERLEY

Acknowledgements

I would like to thank the following for their invaluable help: David Addy, Lorna Allen, Ted Ashton, the British Museum, Bury Free Press, Edna Coote, Brian Cross, East Anglian Newspapers, Robin Goodchild, Andy Green, Richard Green, Sarah Green, Robert Halliday, Jack Hobhouse, Chris Lale, Bury Past & Present Society, R. Pawsey, Peter Plumridge, Gerry Nixon, Teresa Peck, Daphne Pike, Robinson Portfolio, John Saunders, Shutterstock Support, Michael Smith, St Edmundsbury Council, St Mary's church, Suffolk Records Office, Geoff Taylor and my ever-patient wife, Sandie.

First published 2016

Amberley Publishing
The Hill, Stroud, Gloucestershire, GL5 4EP
www.amberley-books.com

Copyright © Martyn Taylor, 2016

The right of Martyn Taylor to be identified as the Author of this work has been asserted in accordance with the Copyrights, Designs and Patents Act 1988.

ISBN 978 1 4456 5416 4 (print)
ISBN 978 1 4456 5417 1 (ebook)

British Library Cataloguing in Publication Data.
A catalogue record for this book is available from the British Library.

Typesetting by Amberley Publishing.
Printed in Great Britain.

Contents

Introduction 4

Angel Hill 5

Bell Meadow 8
Bullen Close 9
Brentgovel Street 10
Bridewell Lane 12

Church Row 14
College Street and
 College Square 15
Corsbie Close 16
Cotton Lane 16
Crown Street 18
Cullum Road 19

Durbar Terrace 20

Eastgate Street 21

Fornham Road 24
Friars Lane 25

Guildhall Street 26

Hatter Street 30
Homefarm Lane 33
Honey Hill 34
Hospital Road 36

Ipswich Street 38

Jacqueline Close 39

King's Road 41
Klondyke 44

Langton Place 45
Long Brackland 46

Maundy Close 49
Maynewater Lane and
 Square 50
Mermaid Close 51

Mill Road 52
Minden Close 53

Northgate Street 54

Out Risbygate 58
Old Dairy Yard 60

Pea Porridge Green 61
Peckham Street 62
Priors Avenue 63
Prospect Row 64

Queens Close 65
Queens Road 66

Risbygate Street 68
Raedwald Drive 70

Sparhawk Street 71
Southgate Street 72
St Andrew's Street North 74
St Botolphs Lane 76
St Edmundsbury Mews 78
St Olave's Precinct 79

Tayfen Road 80
Thingoe Hill 81
The Vinefields 82

Unicorn Place 84

Victoria Street 85

Westgate Street 86
West Road 88
William Barnaby Yard 90
Woolhall Street 91

'X'-Chequer Square 92

Yeomanry Yard 93

Zulu Lane 94

Introduction

Bury St Edmunds is reputed to be the oldest purposely laid-out town in the country in alignment to the magnificent abbey church of St Edmund. The medieval grid laid out by Abbot Baldwin of St Edmundsbury Abbey from 1065 is still evident today. The cartographers of yesteryear such as the father and son Thomas Warrens could still follow the town centre today. The subsequent stories behind these streets and many others are fascinating – how they were named, who lived where, what was there and what is there now. This book sets out to tell some of these tales but in an unusual way, alphabetically. Starting with the letter A, the book progresses through the whole alphabet with every letter covered, ending of course with Z. The X did pose a headache, but read on to find out how it was resolved. As with a scrabble board some letters are more popular than others, and this reflects in the number of corresponding roads, streets, lanes, etc. The many photographs enhance the facts, stories and yarns using pictures from the past and the present. Obviously, some streets have more to offer than others, and it is not my intention to try and cover everything; you could write a whole book on Abbeygate Street, for instance. This collection of vignettes of over sixty locations is an eclectic mix of pubs, people and places; buildings and architecture, churches to chapels along with those little local anecdotes that will appeal to a wide readership – residents and visitors alike.

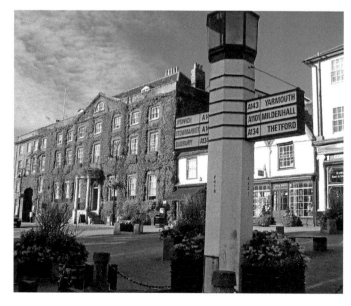

The Pillar of Salt road sign, Angel Hill.

A

Angel Hill

From medieval times when it was known as Le Mustowe, the Muster and also God's Square, this large open space has been used for many purposes over the years, from the celebrated ancient Bury Fair (abolished 1871), civic ceremonies such as Freedom of the Borough and Remembrance Sunday and in recent years the very popular Christmas Fayre. Angel Hill curves around Crescent House past the ancient One Bull, which has a barrel vault, and to Nos 19 to 21, both fine timbered properties. The iconic Virginia creeper-covered Angel Hotel now lends its name to the hill. The hotel, built on the site of three inns, the Castle, the Angel and White Bear, dates from 1779 and was designed by Harleston architect John Redgrave. Denuded of creeper a few years ago, the Suffolk white-bricked building looked very stark; supposedly the reason for the removal was that mice were climbing up the creeper into the bedrooms and the audible screams were not of newly-wed marital bliss! Thankfully, all is back as it should be. There is also now the 'trendy' Wingspan Bar in the undercroft, a groined vault from medieval times. The Angel's connection with Charles Dickens is well documented. The Victorian author of social conscience stayed here and so did his eponymous hero Samuel Pickwick. Dickens carried out readings at the nearby Athenaeum, once assembly rooms for the great and

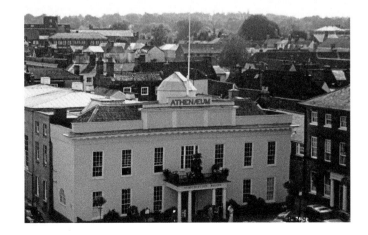

The Athenaeum

the good of Bury society during Georgian times. When banker James Oakes, 'Mr Bury St Edmunds' of his day, purchased the building in 1801, he then conveyed it a few years later to some members of the thirty-seven-man corporation – hence Subscription Rooms above the portico. The internal parts of the Athenaeum stretch back centuries, and an Adam-style ballroom and an observatory perched on the roof. The cultured people of Bury who belonged to the Athenaeum Club (established in 1854) had the observatory built there soon after a lecture given by Astronomer Royal George Airy in 1859.

Does Angel Hill have a warren of tunnels leading to and from the abbey as we are led to believe? Did an intrepid violinist at the end of the eighteenth century really leave the Angel Hotel via one such subterranean route accompanied by other revellers? The story goes that as they were heading in the direction of the abbey, fear overtook the bravado of his colleagues until he was left alone playing his fiddle; his chums followed his tune above until no more was heard of him. Ooh-er! The stories of ancient tunnels can be taken with a 'large pinch of salt'. Another salty story is of a listed traffic sign designed in 1935 by Basil Oliver, the architect of the former borough offices, listed as it did not conform to normal traffic regulations. Its moniker is the 'Pillar of Salt' after the story of Lot's inquisitive wife in the Bible. It is the only structure in the world with that appellation. Opposite is perhaps the most used icon of Bury St Edmunds, the Abbeygate. This is the second secular entrance to the abbey; the first was opposite Abbeygate Street and was destroyed in riots by the townspeople in 1327, a year of national unrest with the grim demise of Edward II. Bury's rebellious inhabitants were severely unhappy with their lord and master, the abbot of the abbey who owned and taxed the town. A new gate in the English Decorated style, with niches for statues and embellishments, was finished twenty years later (the portcullis is a Victorian replacement). After suitable punishments were administered, the town eventually settled down until the Peasants' Revolt in 1381. This time things really got nasty; two officials, Sir John Cavendish (the king's

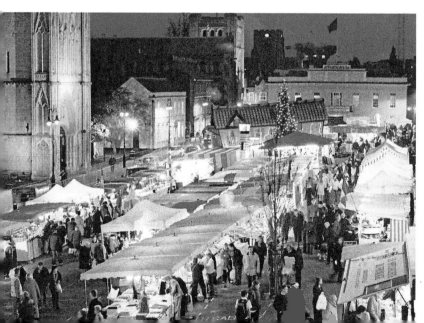

The very popular
Christmas Fayre.

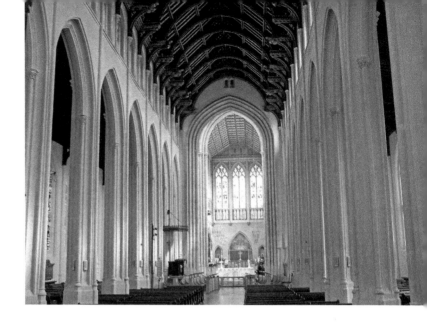

Interior of the cathedral.

chief justice) and Prior John Cambridge were beheaded, and their heads displayed on pikes in the great market (Cornhill). In the aftermath the town was heavily fined and the rebel leader John Wrawe received a traitor's death.

St James's parish church became a cathedral in August 1913, the diocese of St Edmundsbury and Ipswich being created from parts of Norwich and Ely dioceses in January 1914. Bury St Edmunds has the cathedral, as Ipswich did not have a church that could be extended, and the bishop sits in Ipswich. As St James's church (mainly sixteenth century), it had master craftsmen work on it through the years, including King's College mason John Wastell. Modern-day craftsmen really came to the fore when the twentieth-century diocesan architect Stephen Dykes Bower, who had carried out the extensions from 1960, left money in his will for the building of a tower. His vision was finally carried out with the help of a Heritage Lottery grant, which saw the work start in 2000 – it was named the Millennium Tower. One thousand metric tonnes of brick and the same in stonework allowed England's last uncompleted cathedral to be finished five years later. The pages of a book of remembrance from the First World War in the cathedral are turned daily, the names of the 'glorious dead' not being recorded on the Angel Hill cenotaph which was unveiled in August 1921.

Other victims not of war but of beliefs are recorded on the Protestant Martyrs Memorial in the nearby Great Churchyard. It was somewhere near to the Queen Anne Angel Corner that 'Bloody Mary's' chancellor Stephen Gardiner was born, the son of a Bury cloth merchant. He rose to prominence as the secretary of Cardinal Wolsey, who came from Ipswich. History has it that Bishop Gardiner was somewhat responsible for the pyres that claimed hundreds during Mary's five-year reign, during which she tried to reintroduce the Catholic faith. Other fire connections on Angel Hill at different times were at Nos 9 and 12 where thankfully no one died, though at No. 7a in 1929 a fire at the premises of electrical engineer Rowland Todd tragically resulted in the death of nine-month-old Trevor George Todd despite the valiant efforts of fireman Baldwin, who brought the baby out of the burning building.

Bell Meadow

This large cul-de-sac development owes its name to a medieval draper John Perfey, a tenant of the manor of Fornham All Saints. After returning from the Manor Court, he is said to have lost his way home in fog and was in a 'perilous situation' as quoted in one account; the land here is probably marshy due to its proximity to the River Lark. Then he heard St Mary's church's curfew bell toll, and using this for guidance he made his way home. This bell was rung to instruct the town's gatekeepers to close the gates for security. By his will of 1509, he left some land to the churchwardens of St Mary's in order for a bell to be rung at 4 a.m. and 9 p.m. during summer and at 6 a.m. and 8 p.m. during winter. The ringing of the curfew bell was only discontinued in recent years; the land, now aptly named Bell Meadow, was owned by St Mary's until being sold in 1926. In 1863, a filtration plant was opened in Bell Meadow – the first real attempt to deal with the town's sewage. Just a few years ago, footings being dug for an extension to a property uncovered an unwelcome feature, a large red-brick culvert. Thought to be part of the sewage works, it ran from Bell Meadow diagonally to the rear of the Tollgate public house. A section of it was large enough to stand up in; the cost of filling it up with concrete at the behest of the building inspector was an unexpected expense for the homeowner! The exact nature of this has never been properly understood or explained; perhaps it was linked to the settling tanks and was carrying water to the River Lark.

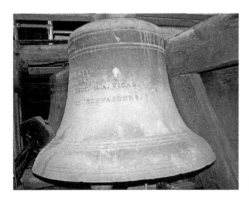

One of St Mary's bells.

Bullen Close

Bullen Close and Pinners Way, part of a mixed development of detached/semi-detached houses and four blocks of flats off Hospital Road, were built during the 1990s by Trend Housing, later Caspian Homes of Newmarket, on the site of former allotments backing on to the borough cemetery. In 1782, Henry Bullen was an upholsterer of Buttermarket and was a common councillor on the Bury Corporation. During the mid-nineteenth century, the Bullen family began acquiring land and property in the Mill Lane area as it was known then; Limekiln Cottages and Lucern Cottages were owned by them. In 1845, Henry's grandson Thomas George Bullen had purchased some land called Pinners Folly that had a large amount of chalk workings on, part of it to become the disastrous Jacqueline Close. Thomas George Bullen has his initials from 1848 on a garden wall in Mill Road, and Bullen's lime kilns are shown on Bury maps. Thomas sent two sons to Bury Grammar School; Thomas George junior became a solicitor; the other, Henry, rose to the pinnacle of Bury society, becoming mayor in 1905. The family businesses were certainly diverse, consisting of lime burning, upholstery, furniture dealing, insurance and estate agents! Henry's shop was at No. 20 Buttermarket (a Starbucks in 2016) and was going until his death in 1923.

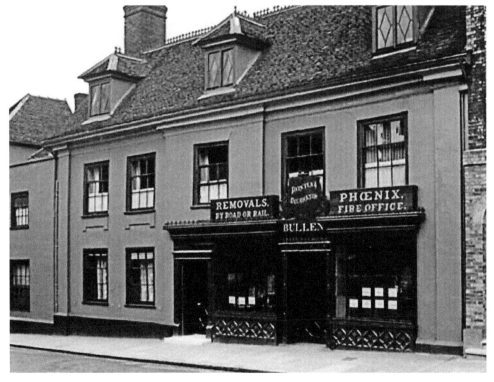

Bullen's Shop, Buttermarket.

Brentgovel Street

This name supposedly means 'burnt ground', and the street runs from Risbygate Street until it meets Looms Lane. Many changes have taken place here over the years from when it was a major through road for the town; the Eastern Counties Omnibus Station was situated slap bang in the middle. This is gone, a McDonald's is now on the site. Opposite here was the wonderful art deco cinema of Oscar Deutsch, which opened in 1937. Containing 1,300 seats, it was the first to be purposely designed for sound films but also had provisions for an orchestra as well as a stage; many a child can remember attending 'Saturday morning pictures'. It was renamed the Focus in 1975, but attendances dwindled; maybe a refurbishment might have helped, but the final curtain fell in 1982. Demolition followed, along with the auctioneer premises of Chevell Lawrence, the barber shop of Ethelbert Taylor and the White Lion public house on the corner with Short Brackland. This dated from the middle of the eighteenth century and was a carriers' inn at one time, their heavy wagons laden down with all sorts of merchandise. 'Ladies of the night' were also reputed to have plied their trade at one time in the darkened corners of the Lion yard. Throughout the twentieth century many market stallholders kept their stalls under cover here. In place of these buildings is an extremely dubious shopping mall, Cornhill Walk – an eclectic mix of shops to give you a wonderful shopping experience, so we were led to believe. Well, not so, as in September 2015 this retail centre, which suffered badly by the opening of the Arc complex, was in receivership awaiting an uncertain future.

The loss of the White Lion was preceded by the closure of the ancient Kings Head on the corner with St John's Street in 1976; this was replaced with a Mothercare store, now Hughes Electrical, though a wonderful weathervane consisting of a stork carrying

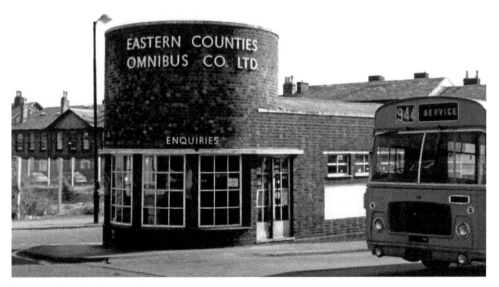

Eastern Counties bus station.

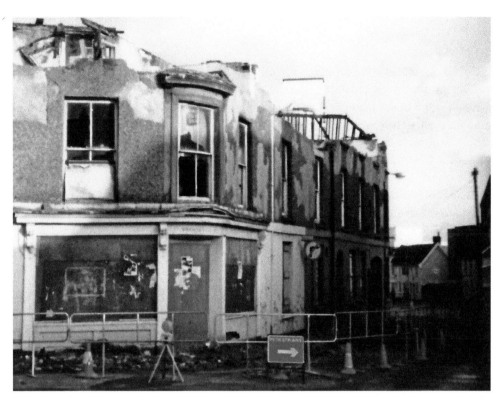

The demolition of the White Lion.

a baby has been retained. Further along is the Grapes Inn, a hostelry once owned by Henry Braddock and his Southgate Brewery during the nineteenth century, when it was known as the Cock Inn. This was also the site of the Risbygate, which was pulled down in 1765, and where a stone chapel stood in medieval times. On the other corner, a variety of businesses have traded, including Glasswells furnishers (celebrating their seventieth anniversary in 2016) in a new development that swept away Flittons' fish and chip shop restaurant; locals called it 'Flittons, spitting and gritting'! Further along was Hawkins fish bar, the premises are awaiting a new future. Opposite to Hawkins' premises at No. 6 Brentgovel Street in 1905 was the Montgomery Company, who produced their own motorcycle and sidecar combination. This shop was to later become Scotts cycle shop and then Halfords, part of a national chain. Another shop now gone was Townsends, a toy shop par excellence, Moyses Hall Museum in 1996 having extended into the former premises (it was a Brewhouse way back in 1540). The Methodist church has been much altered internally and externally since it was opened for worship in 1878. James Floyd, a chemist shop owner and an ardent Methodist, was very much to the fore of its building; he was to become mayor two years later. With the amalgamation of the three branches of Methodism in 1934, it was renamed the Trinity Methodist church. Perhaps the biggest change is the pedestrianisation of part of the street from the corner of St John's Street to the Well Street corner. Is this the future of Bury's town centre?

Bridewell Lane

The Bridewell was a London Tudor palace given by Edward VI to the City of London Corporation for orphans and wayward women; the name has come to be associated with a local jail or 'nick' for miscreants. Any evidence of it being here has been lost in the mists of time because on Warren's map of 1776 it is shown as Mr Andrew's Street, whoever he was. The Greene King Brewery dominates the southern part; its co-founder Benjamin Greene with partner William Buck purchased Wrights Brewery to become the Westgate Brewery in 1805, not the erroneous date of 1799 as is often quoted. Although the original 1968 buildings are still there, built on the former Watson's timber yard, the Brewery fire brigade finished in 1997, having provided over many years a professional firefighting service, supplementing the boroughs. The school adjacent is that of the Guildhall Feoffment from 1843, one of two (the other in College Street) built to designs by Henry Kendall as the Poor Boys School at a cost of £1,650. The large hall here is listed with a fine 'Jacobean style' hammer beam roof. In 1882, further classrooms were added and repairs undertaken. Next to the entrance is the former headmaster's house, whose pay in 1844 was £70 per year and one old penny for each boy per week! The school had a capacity for 300 pupils, so unsurprisingly it was in his interest to make sure it was well attended! After the Second World War, temporary huts with the acronym HORSA (Hutting operation for raising of school -leaving age), were added. Constructed from prefabricated concrete walls, asbestos roofs and metal-framed windows, they are

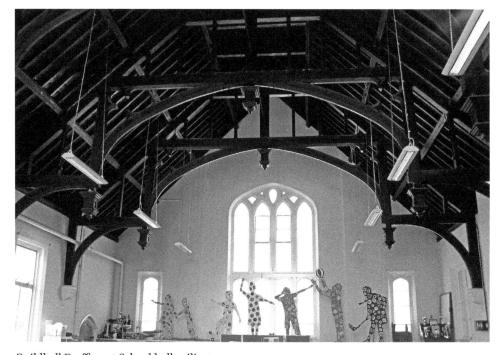

Guildhall Feoffment School hall ceiling.

The Blackbirds no longer singing.

being replaced with new extensions with the mandatory archaeological dig uncovering remnants of flint walls from a medieval kitchen. Today the school is very popular, with children attending from outside the catchment area.

Bury St Edmunds has a medieval grid often referred to as the Historic Core, making it one of the oldest purposely laid-out towns in the country. Off these streets, courts, yards and squares proliferated the town, Bridewell Lane being no exception with Church Walks and Tuns Lane still there. Gone is St Mary's Place, a row of eight cottages; new builds at Nos 2 and 3 are now opposite on the former builder's yard of Lennie Sewell. Lennie lived at Hardwick Manor and was mayor of Bury in 1964. No trace of the eight houses in Finsbury Square exist and now only garages are there; it was named after the Finsbury Arms (No. 18), which closed its doors in 1922. This was once part of a fifteenth- or sixteenth-century hall house with its neighbour (No. 16). When Blomfield House in Lower Baxter Street was demolished to make way for a clinic, its Greek Doric door-case was added to No. 16's portico, fluted columns and all! The Blackbirds pub at No. 14 called finally called time in 1973. The last landlord of this popular pub was Neville Green.

As with other clubs in the town, the Roundel Club is no more and has now reverted to a private house called Bethany; a date stone on the rear gives a date to this Dutch-gabled house of 1793. The Roundel Association was formed in 1944 and was popular for socialising, having a thriving concert club in the 1960s, cribbage and darts teams. However, membership waned and the premises closed in the 1990s.

Church Row

On Warren's 1741 map of the town only a few properties are shown in this area, then one of the less fashionable parts of Bury St Edmunds. After the building of St John's church in 1841–2, this street came into being and Church Terrace was built, a long row of typical Victorian cottages. With the slum clearances of the town in the 1960s and 1970s, some houses at the bottom on the north side were demolished. Also removed was Frank Mudd's yard; he had started off in business as a dairyman and coal merchant at No. 8. Mudds then progressed to furniture removals until taken over by national removal company Pickfords in 1982. A residential home run by Stonham Housing is now on the site appropriately called Mudds Yard, part of it fronting on to Church Row. The Lathbury Institute (mission room) for St John's Parish was intended for extra parochial activities and was built by the means of a gift of land by Revd Dr Stantial and a generous bequest of £400 from Elizabeth Horatia Lathbury's will of 1896; she had died aged seventy-six in 1893. Elizabeth had lived with her sister Mary at No. 6, Angel Hill (until recently the Tourist Information Centre). A stone plaque with the date of 1816 and the initials of S. L. is on a boundary wall to the new Lathbury Court properties behind the Institute which has now been remodelled as a house by local builders Mothersoles, who are also responsible for a fine sympathetic extension known as Church Cottage.

The former Lathbury Institute.

College Street and College Square

Renamed College Street from Barnwell Street, the college this refers to was not a seat of learning but a retirement home for priests from St James's and St Mary's. The College of Sweet Jesus was founded by one of the town's great benefactors Jankyn Smyth under the terms of his will of 1480. His annual endowed service from 1481 is still carried out in St Mary's, thus possibly making it the oldest such service in the country. For many years the exact location of the college could not be confirmed, but during the building of a new house in 2014 on part of the old workhouse site, a large cellar was found with a well-constructed flint wall and a limestone block-edged corner to a cellar staircase, all of which indicated medieval occupation. Two tenements owned by the college provided rents for maintenance while four were for poor people; these were probably opposite where the William Barnaby almshouses were to be later. The college ended in 1549, ten years after the dissolution. Two hundred years later, a more stringent place for looking after the town's poverty-stricken people was opened in College Street, the Bury Workhouse. The guardians of the poor in Bury were allowed to purchase the former college and develop the site to accommodate a growing number of vagrants and paupers by an Act of Parliament. With the opening of the Thingoe Union Workhouse in 1837 in Mill Lane, the days of the College Street workhouse were numbered. By the end of the nineteenth century, the Guildhall Feoffment Trust had assimilated various charities, mostly from medieval times, which allowed them to build new almshouses in the town. These bedsits in College Square were designed by Archie Ainsworth Hunt and opened in 1909. A delightful oasis in the town centre just off College Street, it has a warden-controlled office, its residents have to be over sixty and must also be of a certain financial disposition. A large oval plaque to benefactor John Frenze detailing his charitable endowment of 1494 is on one of the bedsits.

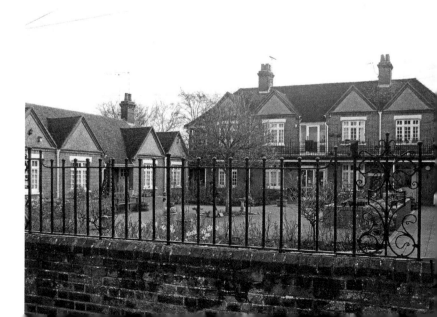

College Square.

Corsbie Close

This is part of the Cathedral Meadows development of fifty traditionally built three-storey mews, detached and terrace houses off Cullum Road. Only a five-minute walk from the town centre, their value has shot up since they were built in 2000. The developer was Land Charter Homes PLC, who was also responsible for Drovers Mead on the Moreton Hall Estate and Abbotsgate on the former Hardwick Industrial Estate, which is still awaiting completion. The latter is a brownfield site, as was the Cathedral Meadows location. At one time this was Atlas Works, from where various small companies such as PEP Engineering and Armorex Resin Flooring operated. Corsbie Close is named after John Corsbie, who was born in 1722 in Norfolk to John Corsbie, a weaver of Ashwellthorpe, Norfolk. John junior came to Bury St Edmunds in around 1756 and married Sarah Cumberland, the daughter of wealthy Samuel Cumberland, a yarn maker who lived at No. 24 Westgate Street just around the corner from Cullum Road. As the wool trade was still reasonably buoyant in the town, John could purchase No. 24 in 1758 from his father-in-law. He then took over the family business when Samuel died two years later in 1760. John was a prominent member of the Independent Chapel in Whiting Street, later to be the Congregational Church, now the United Reform Church. He had a son and three daughters and, as an enlightened man, he associated with like-minded people; a close friend was another yarn merchant, William Buck, who went on to live in No. 24. Buck's daughter Catherine married Thomas Clarkson, who was behind the 1833 Emancipation Act that abolished slavery throughout the British Empire. As the wool trade diminished; William Buck went into partnership with brewer Benjamin Greene, John Corsbie having died in 1796.

Cotton Lane

This narrow lane once accessed from Northgate Street in two places is now only accessible from Mustow Street, where it is used mainly as a route to the Ram Meadow car park and Bury Town's football ground. Cotton Lane has had different names in

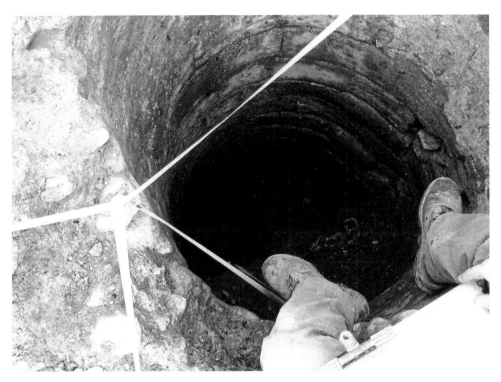

Scurun's Well?

the past, Scurff Lane and Skoron Lane. The latter probably evolved from Scurun's Well, where the cellarer of the abbey had property. In 2012, an archaeological dig in preparation for a retirement complex called Crosspenny Court, fronting Cotton Lane, uncovered medieval occupation, including a very fine well with curved limestone blocks – evidence of a high-status owner? In the mid-fifteenth century a chaplain with the strange name of Edward Qwysson was connected to a property on the corner of Scurff Lane and Mustow Street; his surname is continued today in a housing development on the former E. B. (Ernest Boughton) Packers site just off Cotton Lane. Warren's map of 1791 shows meadows to the east of Cotton Lane owned by two members of the clergy, the reverends Charles Legrice and Orbell Ray. The west side has gardens coming down from houses in Northgate Street; one of these was the surgery of Sir Thomas Gery Cullum; his son – another member of the cloth, also named Thomas Gery Cullum – has his initials and the date of 1834 on a house called Allandale in Cotton Lane. Though never built up, in recent years the west side has seen more housing built, such as Redwood Gardens' sheltered accommodation in 1988 while opposite the former Eastern Counties Bus servicing garage (once Westgates Garage) is a prime site awaiting development. One area that will hopefully never see the bricklayer's trowel is that of the allotments, a prized asset of the town that stretches to the A14 link road. The only real concerns these dedicated growers have to contend with are the muntjac deer munching their way through their vegetables.

Crown Street

Originally, this street only went from Westgate Street to the corner of Honey Hill; from there to Churchgate Street it was known as Church Govel Street – the govel element being a feudal rent. The fifteenth-century St Mary's church commands the area as it is one of the largest parish churches in the country. The impressive nearby Norman tower, once the religious gateway to the abbey, was saved by the intervention of architect Lewis Nockalls Cottingham during the mid-nineteenth century as it was in danger of collapsing. His schedule of remedial works conserved this fine 80-foot-high twelfth-century belfry of Abbot Anselm for posterity; it has thirteen bells now. Adjacent is Norman Tower House, a pseudo-Jacobean house from 1846; built in three stages to designs by Cottingham as a savings bank, it is often erroneously referred to as Penny Bank House. Along the street at No. 43 was the Three Tuns public house; it closed in 1903. It became Lansbury House after George Lansbury, once chairman of the National Labour Party, and was the local Labour Party headquarters from 1949 to 1997. Further down the street is the Dog & Partridge, whose origins go back to the seventeenth century when it traded as the Mermaid. Many alterations have taken place over the years, such as making the bar area open-plan and putting more emphasis on food. Close by is the GK Brewery boiler room; a tunnel under the road connects it to the brewhouse. Previously a house on the boiler room site was the home of the thirty-third and last abbot of Bury Abbey, John Reeve aka Melford. A capable man, he was awarded an enormous pension after the monastery was dissolved in 1539 but never collected it, dying within a year of a broken heart; he is buried in St Mary's. Opposite the brew house are four cottages, the first brewery workers' homes built by Edward Greene in 1859, and further along was the studio of artist Rose Mead with its blue plaque of 2012.

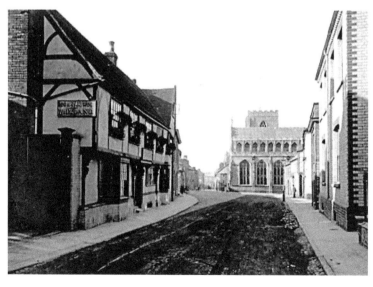

Looking down nineteenth-century Crown Street.

Cullum Road

Surprisingly, there were thirty-three properties in Cullum Road before the Second World War; in those days it finished near today's Cathedral Meadows. Now it is a completely different story; it is an important arterial route from the Westgate corner with Parkway up to the Nowton Estate roundabout, which ultimately leads to the A14 or the West Suffolk Hospital. Cullum Road opened in 1973 and was named after the important Cullum family of Hardwick, where the hospital is sited. The road construction meant that the land had to be raised to stop it from being permanently flooded, as it went through water meadows, watercourses and over the River Linnet, which was diverted, sent through a culvert. The road-building problems were to reoccur some years later when Greene King put in an application to create an access road for their lorries from Cullum Road. Despite much opposition, led chiefly by Bury resident Doreen Tilly with her Water Meadows Defence Campaign and aided and abetted by so called eco-warriors, the five-year legal campaign ended with the road opening in 2002. The water meadows, loosely called the Butts, were once part of Almoners Barn farm, which was owned by the abbey in medieval times. At the end of the First World War, some of these meadows were planted with flax to make linen for aeroplane wings; the flax factory was at the now defunct Hardwick Industrial Estate. The terrace houses on the east side of Cullum Road are also now gone; in their place is a residential care home called No. 11 Cullum Road, run by Orbit Housing Association. An archaeological dig here in 2000 in preparation for its construction uncovered shards of Roman pottery from the third and fourth centuries, along with animal bones that show signs of butchering, the first clear evidence of some Roman occupation in the town.

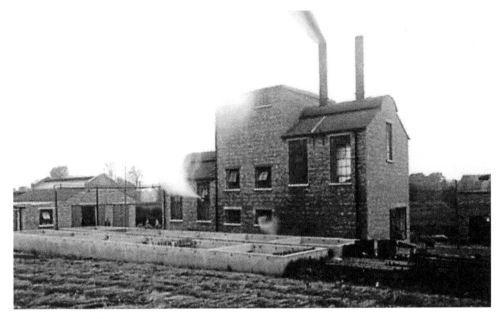

The former flax factory.

Durbar Terrace

Now a no-through route for vehicles, it is still a handy shortcut for pedestrians between Springfield Road and Spring Lane, but was once part of ancient Pudding Lane which carried across Springfield Road and then ran parallel with Risbygate Street. Today, an unmade track leads to garages and forecourts at the rear of the fire station in Parkway North. The five red-brick terrace houses from 1904 were named after a durbar, which was a court of an Indian prince where a public reception was held. There were three durbars held between 1877 and 1911. The first was to celebrate Queen Victoria being given the title of Empress of India. The second was in 1903 when it was held in honour of Edward VII. He did not attend but sent his brother Arthur, Duke of Connaught, to represent him. It was a splendid affair well organised by Lord Curzon, Viceroy of India. Lord Curzon has an interesting connection with Bury St Edmunds via a Victorian writer, Ouida. A memorial was erected to her at Stamford Court in 1910 by subscriptions raised by readers of the *Daily Mirror*. On a bronze panel on this drinking fountain/trough part of her epitaph says, 'Her friends have erected this fountain in the place of her birth. Here may God's creatures whom she loved assuage her tender soul, as they drink. Curzon of Kedleston'. He was reputably a friend though Kedleston, Derbyshire, is miles from Bury St Edmunds. The third durbar was held to celebrate George V and Queen Mary's visit to be proclaimed Emperor and Empress of India and also to announce that New Delhi was to be the capital of India instead of Calcutta. Over half a million people joined in the celebrations. In 1916 Durbar Terrace narrowly escaped destruction from a Zeppelin, with nearby houses in Springfield Road receiving most of the damage, and a horse in the stables at their rear received terrible injuries and had to be destroyed.

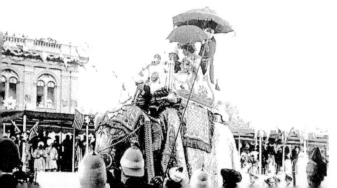

Lord and Lady Curzon at the 1903 durbar.

Eastgate Street

Along with the other four town gates, the East Gate was pulled down in the 1760s to allow traffic to flow more easily. Part of the chimney belonging to the gatehouse is just visible by the abbey's north curtain wall opposite the Fox Inn. This has a rightful claim as the oldest in the town; now an open-plan gastropub, its origins are from the fifteenth century, when the emphasis was on ale. After 500 years, a truly wonderful timber roof with arched braces, tie beams and crown post from when it was a hall house, is concealed beneath a later roof. Just outside on the Broadway is a drinking trough donated by Lady Bunbury of Great Barton Hall in 1875. A tap was at one end for the drovers that used Eastgate Street as a major thoroughfare to Bury livestock market, though I suspect they preferred to slake their thirst inside the Fox. An engraving by Richard Godfrey in 1780 shows the Fox not dissimilar to today but with a very different Eastgate bridge over the River Lark, including an almshouse built on it in 1612. This was demolished in 1838, and the current bridge was built by William Steggles & Son by 1840. Having stood the test of time for 128 years, it was wrongly blamed for the terrible floods in Bury in 1968 as not fit for purpose. A Bailey bridge was proposed in 1978 with the Anglian Water Authority even prepared to spend £300,000 on the demolition and building of a new bridge. Local residents vehemently opposed the plans, and they won through with the support of Eldon Griffiths MP. The Steggles Bridge is still there, Grade II listed and still doing a good job.

The Fox.

In 1680, by the side of the River Lark near the Fox, a ducking stool was established 'for punishing scolds and cheats'. A plank with a chair at one end was swivelled over the river and the unfortunate soul was dunked whether the water happened to be foul or fine; it was removed in 1838. Across from the bridge was Eastgate Infants School of 1872 (now offices); it was one of several schools built in Bury from the middle of the nineteenth century. Further along is Eastgate House, now part of a retirement home complex from 1985 and run by Sanctuary Housing; the properties are in the garden of previous owner Mrs Dimock. Another owner of Eastgate House was Sir Thomas Hanmer, speaker of the House of Commons in 1714 and one of the first editors of Shakespeare's works. A plaque was put here in 1907 to reinforce the historical and cultural links with the town's past in preparation for the pageant of that year. Unfortunately, the plaques were never properly researched; for example, the erroneous plaque to Daniel Defoe on Cupola House and it may well be that Hanmer's home was in fact not Eastgate House. From when it opened in 1865 to its closure in 1909, Eastgate railway station stood where Bury Bowl is today; the Bury A14 bypass, which opened in 1973, follows the old Bury to Long Melford line, which was demolished by 1924. Also gone (the Greyhound remains) are four pubs: Unicorn, Suffolk Hunt, Ship and the Ram, from where Bury Town FC got the name of its home ground, Ram Meadow. The Ram, an ancient inn, was owned at one time by the Maulkin family, wealthy maltsters in the town. Emily Maulkin married farmer Frederick King in 1852. He would go on to build up a valuable portfolio of pubs in Bury, which would in turn lead to an amalgamation of his St Edmunds Brewery with that of Edward Greene's Westgate brewery in 1887 – known today as Greene King.

Sudbury to Bury railway bridge.

Bury Grammar School's home for 115 years.

In July 1969, the old Eastgate Street Mission Room, close to Charlie Allen's cycle shop, caught fire; the Victorian building was completely gutted. Laymar Ltd had been using it to store flooring materials. A new showroom with flats above was built on the site, rising like a phoenix out of the ashes. The same could not be said of the terrible conflagration of 10 April 1608, which started in Randalls the Maltsters somewhere near Barn Lane. The fire soon took hold and swept down Eastgate Street, consuming all in its path. Somehow the wind carried it away from the Fox and up Looms Lane into the town centre, destroying properties and warehouses. Such was the fire's ferocity that the lead ran 'like a molten river' from the roof of the engulfed Market Cross. It raged for three days and was only brought under control with fire breaks – houses being pulled down using long poles with hooks on the end called cromes. The after-effects were enormous; though no lives were lost, many people were ruined. King James I sent 500 cartloads of timber to help rebuild the town and issued a 'Royal Brief', a warrant whereby church collections would go to a relief fund. The Bury St Edmunds Brief is dated 18 June 1608. As a result of the catastrophe, the use of thatch was banned in the town. On the corner of Barn Lane is Ancient House, home to Bury Grammar School from 1550 until it moved to Northgate Street in 1665; it too escaped the ravages of the great Bury fire. During the latter part of the nineteenth century, Ridley and Hooper had a tannery here.

Fornham Road

Once known as Northgate Road, Fornham Road starts at the architect Charles Russell's splendid railway bridge of 1846. Another nearby link to the railway is the former Railway Mission Hall now described as a 'tin tabernacle'. Funds to buy this prefabricated corrugated structure were raised by the railway workers themselves and it was purchased from Norwich firm Boulton and Paul in 1900. During the Second World War, German POWs encamped at Fornham sang here as a choir. It has been restored in recent years and is now listed; its usage is still religious, but the congregation is now the Seventh Day Adventists. Nearby, construction work on a garage in the mid-1960s was underway when several skeletons were discovered, probably from the medieval chapel of St Thomas which once stood there. Opposite are the ruins of St Saviours Hospital, founded by Abbot Samson in 1184. Saint Saviours was more of a hospice for the soul at this time, medical help being very basic in those days. Above the frontage is a plaque put up in 1907 (at the expense of George Cullum of Hardwick) to Humphrey, Duke of Gloucester, Henry VI's uncle. The king called Parliament to meet at Bury in 1447, where Humphrey answered to trumped-up treason charges. While in lodgings at St Saviours, Humphrey was found dead; the official cause of death was stated as apoplexy, a stroke, but it was rumoured that he had been murdered. Tesco funded an archaeological dig between 1989 and 1994 which revealed the extent of the ruins; on completion a time capsule was buried close to the site. The resulting supermarket on this former Whitmore's timber yard has had staff experiencing ghostly manifestations in the storerooms! The building of the A14 flyover in 1971 necessitated the

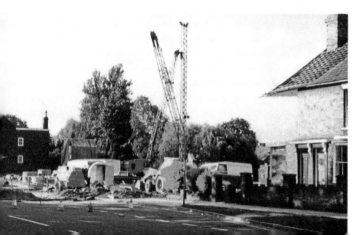

Making way for the A14 flyover.

removal of several properties. Eastwards from this flyover are eight blocks of four terrace houses, Nos 17–47, built at the beginning of the twentieth century and once owned by the Loyal 'St Edmund' Lodge of the Independent Order of Odd Fellows.

Friars Lane

On a 1433 map of Bury St Edmunds this narrow lane is called Le Fryeres Lane and on Warren's map of 1747, Fryers Lane. Both are associated with the Franciscan friars that settled here in 1238, much to the chagrin of the abbot of St Edmundsbury Abbey, Richard de Insula. After twice being removed as possible rivals to Bury's Benedictine abbey, the friars finally settled at the Babwell Fen (today's Priory Hotel) in 1265 with the help of Gilbert de Clare, who had ignominiously led a massacre of Jews in Canterbury in 1264. Friars Lane is now a valuable shortcut over the River Linnet, with footpaths leading along watercourses over York Bridge to the southern part of town. Although never a built-up area, there are two interesting properties here – Kennel Cottage is one of them. Once it was two cottages supposedly dating from 1760; the Grade II listing identified them as a pair, 'a rarity in Bury St Edmunds'. However, one of the most unusual properties in Bury is just over the way – the Crystal Palace. It is built on 'stilts', at the time an ultra-modern design by Michael (later Sir) and Patty Hopkins from 1978. Originally built around a large courtyard, this has now been glazed over during a recent refurbishment and rearrangements of internal rooms as the walls are demountable. The new layout, known as Project Orange, celebrates the sense of space and the views by placing the bedrooms, bathrooms and utility room along the north elevation. There is a new open-plan kitchen, and the living areas are south facing to catch the sun. A large bookcase creates a long library wall. Everything about it is minimalistic – steel and glass. It is a low-energy concept taking advantage of maximum solar gain achieved by the large glazed areas, ahead of its time.

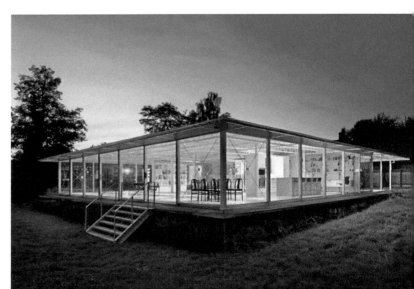

The illuminated Crystal Palace.

Guildhall Street

Part of 'the medieval grid' of Bury St Edmunds, the Guildhall has been identified as possibly being the oldest civic building in the country, dating from the late twelfth century. It is currently undergoing a revamp called the Guildhall Project, where a restoration of the only Second World War Observer Corps Ops room in the country will hopefully be carried out, bringing it up to date with modern facilities, . This can only be done with help from the Heritage Lottery Fund; re-roofing of the slate tile roof has just been completed. The magnificent interior of the roof has a king post and arched braces which extend down into the courtroom where a large painting of James I hangs; he gave Bury its first charter in 1606. Opposite this room is the former council chamber; Bury council meeting was held here for the last time in 1966. A painting to the town's great benefactor Jankyn Smyth hangs in here where it is toasted at the 'cakes and ale' ceremony after his endowed service in St Mary's, which has been held annually since 1481. Jankyn was alderman seven times, gave money for two chancel aisles in St Mary's and, on more than one occasion, paid for the expensive cope the townspeople were obliged to provide when a new abbot was elected. The Guildhall Feoffment Trust had

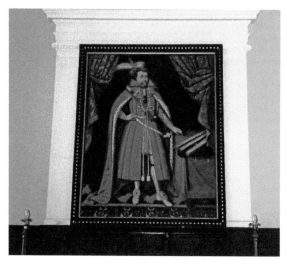

James I.

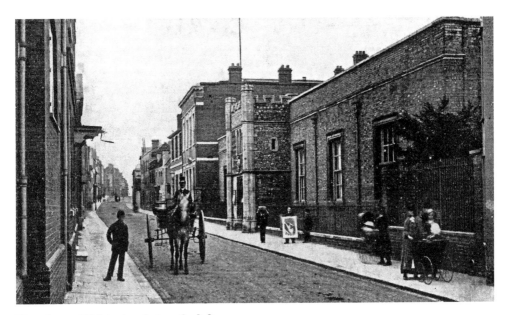

Note the rushlighter bracket on the left.

evolved from the Candlemas Guild and after the abbey was dissolved, they effectively ran the town for sixty-seven years. The Guildhall's fifteenth-century porch, with a splendid internal stone doorway, has a muniments room above with a medieval safe where the Feoffees documents were kept. At No. 79 Guildhall Street, another Norman-style rounded arched doorway is hidden from view – hence Norman House. Thought to be part of a pilgrim's chapel, it once looked directly down Churchgate Street as it would seem this prominent route to the abbey has moved across over time.

Opposite the Guildhall at Nos 80 and 81 are the premises of Greene & Greene solicitors and Ashtons Legal solicitors, respectively, once the homes of Orbell Oakes and his father James Oakes, local bankers. James Oakes was in the wool trade towards the end of the eighteenth century, but with that in decline he went into banking and was joined by his son. James kept a wonderful diary detailing life in Bury from 1778 until 1827, two years before he died. He was alderman on several occasions and an astute businessman even having a pub, the Green Dragon, for his workers to imbibe in. We are not completely sure where it was in Guildhall Street, but James may have been paying his wool workers who worked in his combing sheds in St Andrew's Street South with one hand and taking it back with the other over the bar counter! His home had a banking hall and dining room; wings were later added by notable architect John Soane (who was later knighted). Orbell went on to purchase the manor of Nowton soon after his father died; it may well have been that his father would not have approved of his son's ambitions to become one of the landed gentry. Nowton Court was the Oakes family home for over 100 years. No. 80 has an unusual relic from the past – that of a rushlight holder. It is a twisted wrought-iron bar that protrudes from the doorway overhang, and in the days when there was no street lighting it would have served to illuminate the doorway.

On the subject of pubs in Guildhall Street, there is now only one, the Black Boy. Surprisingly it is over 300 years old and during the nineteenth century was owned by pub entrepreneurs of Bury, the McLeroth family. They had a nearby rival called the Black Girl, which existed for ten years from 1836 to 1846 at No. 68. During the twentieth century, it was the bakery of Oliver Childs and his son Claude; subsequently it was the Golden House chinese takeaway, probably the first in the town. Another pub to have gone is the Three Goats (No. 17); its last vestiges are three goat-like heads on the roof gutter. No. 57 has grapes on its doorway; it was once the former Golden Lion Tap until it closed in 1907, twenty-one years after its brewery in St Andrew's Street South. Other remnants were the Saracen Heads of a brewery and pub of that name. This became the British Legion Club, and when that closed down through lack of patronage, it became The Hunter Club. Owner Andrew Hunter had the heads restored, now on display in the entrance hall. Another business, almost an institution, that closed in 1988 at No. 90 was Andrews & Plumptons ironmongers (now the Royal Bank of Scotland); it lingered on in St Andrew's Street South until 2000. It was a veritable treasure trove of bits and bobs, nuts and bolts, etc. Artist Sybil Andrews was born in the flat above the shop in 1898; her grandfather Fred Andrews had started the business in 1862. Sybil's early work consisted of watercolour street scenes of Bury, but it was her art medium of lino cuts that she excelled at. She immigrated to Canada just after the Second World War with her husband Walter Morgan. Her wonderful banner of Liberty's silk on linen is an interpretation of St Edmund's death and now hangs in the cathedral.

Such a wealth of history in this street warrants more than three pages to even scratch at its surface. Sometimes characters such as the following from the twentieth century need remembering. At No. 7 was the newspaper and tobacconist

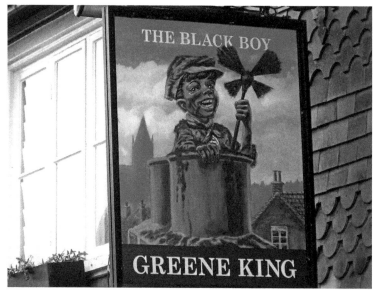

Signage from the past.

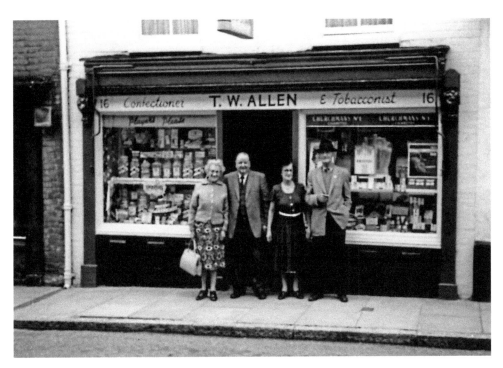

Tom Allen, second from left.

shop of Anne Major-Davies; a heavy smoker, she probably got through quite a bit of her stock every week! On entering her shop, one always seemed to get the smell of boiled cabbage. As I recall, she always wore black, her jet-black hair slicked back into a tight bun, but it was the make-up she wore that made you wonder who she actually was. The face powder was laid on with a trowel, and she used dark eyebrow liner and red lipstick. When she opened her mouth, an alcoholic haze floated by as she did like more than a tipple! On the corner with Churchgate Street was the second-hand book and junk shop of Mr Leslie Peachey. His son Bernie, always referred to as young Mr Peachey, had another shop next to the British Legion. Always professional and polite in their dealings, their shops belonged to another age. At No. 16, Tom Allen in his sweet and tobacco shop was almost the opposite. His play-acting when serving customers made you sometimes wonder how they ever came back, but they did. At the aforementioned Golden House Chinese takeaway, Charlie Chung, the oldest of the Chung brothers, was the personification of customer service. The free prawn crackers you received in your little brown carrier bag from him made you want to come back – service with a smile! The same could be said of Motorspares opposite, a family-run business owned by the Jenkin brothers. Help and advice was always on hand even if a sale was not forthcoming.

Hatter Street

Possibly one of the oldest streets in Bury St Edmunds, Hatter Street has cellars going back centuries. During medieval times it was known as Heathenmen's Street, the Jewish quarter of the town. A terrible incident occurred here on Palm Sunday in 1190 when residents of the town massacred fifty-seven Jews supposedly in revenge for the crucifixion of a young boy called Robert, who was later canonised. However, later theories abounded that Abbot Samson of Bury Abbey had manipulated the incident to excuse paying back money that Abbot Hugh, his predecessor, had borrowed. A poignant memorial to this event stands in the abbey gardens in the shape of a teardrop. At the rear of Nos 25 and 26 are limestone blocks *in situ*, stone being a very expensive building material in the days of timber-framed properties. This was once the premises of printers Pawseys, founded in the nineteenth century and subsequently noted for their almanacs. After the superb town pageant of 1907, Pawseys commemorated the event by publishing a wonderful series of postcards. They detailed the various pageant episodes of the historical events

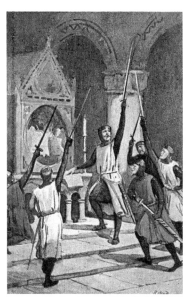

1907 pageant – the barons swear their oaths.

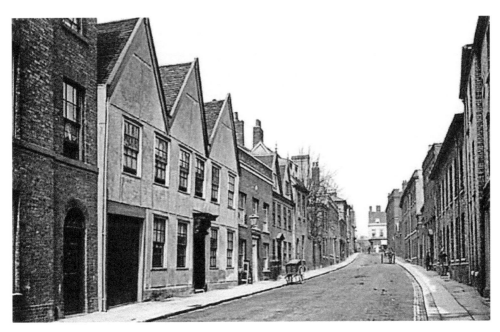

The Misses Wings house, on the left, photgraphed in around 1900.

that have enriched Bury's heritage. Further down the street at No. 15 is another pageant connection to Rose Mead, chief costume designer for the 1907 spectacular. She was born here in 1867 above her father's decorators shop. She studied at the Lincoln and Westminster Schools of Art and in Paris in 1896. Her father died when she was young, and she became a carer for her widowed mother until the age of fifty-two; consequently, she never married. In later life she lived at St Edmunds Hotel, adjacent to the Angel Hotel. This talented artist was found in March 1946 at the bottom of stairs to her studio at No. 18a Crown Street, having broken her neck. Years later, No. 15 was to become the Trustee's Saving Bank and then later a restaurant, the Cantonese. One of the town's favourite eateries, it was run by Patrick Chung with his immediate family until it closed in 2012 after twenty-eight years. Patrick went on to become mayor in 2015–16.

No. 6 Hatter Street has an owner with a wry sense of humour; the house is called Madasa – I will leave you to work it out! No. 7, with its fine Venetian window, and its neighbour, No. 8, have frontages in Suffolk white brick from when they were 'Georgianised' in 1780, but looks are deceptive as to the true age of these listed properties. The middle section of No. 8 is reputably Norman in origins, though there is a Victorian extension to the rear. No. 7 shares a flying freehold with No. 6a; the rafters in the roof are made of oak, but the tie beams are Baltic pine and date from 1200. One of the gable ends is built of wide flint as per the east side of the Guildhall, making this Norman part of the house one of the oldest in Bury. Both these houses were once converted into five flats; they reverted back to two dwellings around 1991. As with other properties in this street, they have limestone blocks possibly *in situ* in the cellar. Nos 7 and 8 were once one house and it was the home of Bury solicitor James Sparke; he had a finger

in every Bury St Edmunds pie during the nineteenth century . As a commissioner in the law courts, a Guildhall Feoffee, clerk to the Thingoe Union, Borough Coroner and churchwarden, he was a very busy man! There is a brass lectern in St Mary's Church to his memory. His father was Ezekiel Sparke, owner of St Andrew's Castle; he died at age fifty-four in 1816. Ezekiel was attorney to James Oakes a one-time wool merchant, famous diarist, banker and Alderman. At No. 18 is a triple-gable house known in the past as the Misses Wings house after school-teaching sisters who lived here in the latter part of the nineteenth century.

No. 4, Hatter Street, aka York House, was once owned by the auctioneer Henry Stanley. The original house was demolished to make way for the Central Cinema, which was opened in 1924 by cinema entrepreneur, Douglas Bostock. As a 650-seater, it attracted large audiences, even overcoming adversity in 1930 when a discarded cigarette set light to a seat and caused severe damage. It was rebranded in 1959 as the Abbeygate; then in 1971 the Star group acquired it and it became two cinemas under one roof, Studios One and Two. For a while it was owned by Cannon Cinemas, but with the growing popularity of videos, attendances declined and one half became a bingo hall. There were various name changes such as MGM, ABC and even Odeon before Holywood Cinemas took it over, and it became the Picture House in 2010. Poor old thing, it must have had an identity crisis! In 2014 the government's Competition Commission ruled that new owners of the then-named Picture House, Cineworld, had to sell it as it was unfair to consumers (a Cineworld cinema is also on Parkway). Picture House manager Pat Church, who has now worked here for fifty years, was over the moon when an independent company then purchased it, saving it for the future. As of 2016 , it is now called the Abbeygate again and has comfy seating and a café.

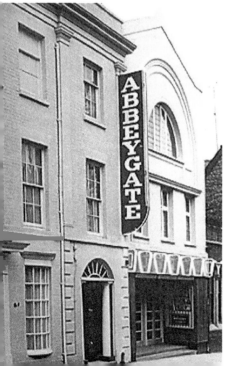

The much-named Abbeygate Cinema.

32

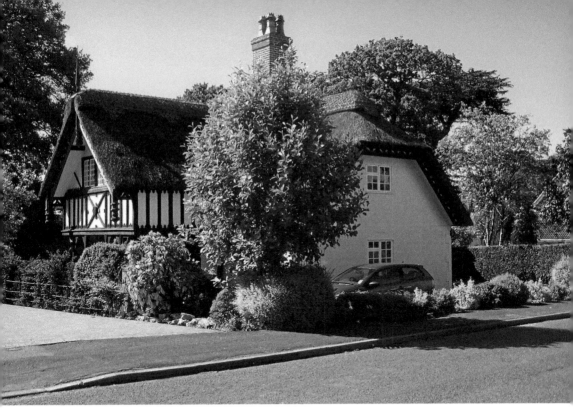

Chocolate box Dairy Cottage.

Homefarm Lane

The Home Farm's function was to provide produce for the owner of an estate – in this case the Cullum family. Nearby Hardwick House was the fine home of the Cullum family until the death of its last male member, George Gery Milner-Gibson Cullum, in 1921. It was claimed by the Crown through the Intestate Act of 1884 as there were no other male members of the family to inherit, and it was demolished in 1925. Homefarm Lane then was un-metalled and led off Hardwick lane to the farm manager's house, today No. 77. As was common with many of the Cullum properties, the letters 'T G C' are here on a pediment on a porch at the rear of this substantial house along with the date 1832, when it was built; Thomas Gery Cullum was a very prominent Bury citizen during the nineteenth century. The five-bedroom Grade II-listed dwelling is white-brick at the rear but has knapped flint panels on the front. Lionel Fulcher, mayor of Bury in 1955, lived here when it was known as Heath House. Further along the lane is Dairy Cottage, now the only thatched property in Bury after thatch was banned as a result of Bury's great fire 1608. Dairy Cottage was separated into two cottages from 1837. Dairyman Ron Walton lived here during 1950s and 60s while working for Fulcher's Dairy. The cottages were used as the site office for a housing development known as Hardwick Vale being constructed at the end of the 1960s, a part of the Nowton Estate. It was made into one property, winning an award in 1973.

Honey Hill

Honey Hill used to finish at Sparhawk Street, from thereon it was known as Schoolhall Street or Scolehallstrete when the abbey's song school was here; the street finished just around the corner into Raingate Street. When the whole area became Honey Hill is a matter of conjecture. Certainly there is a wealth of history here, none more so than at the entrance to the great churchyard. The abbey's St Margaret's Gate was taken down to allow free passage into the churchyard through the garden of an eminent surgeon, Mr William Edmund Image. His response was to have a tunnel dug under the throughway that went from his house (now called St Margaret's Gate) to today's car park at the Shire Hall. The magistrates' courts on this site at the Edwardian Shire Hall by Archie Ainsworth Hunt are under threat of closure after hundreds of years. Opposite is the former Coach & Horses pub which closed in the 1970s. Wells & Winch, a Biggleswade brewery, owned the pub until it was taken over by Greene King in 1961. The story goes that some witnesses had a few drinks in the pub while waiting to give evidence in court, so they were unable to swear the oath. A different type of oath, the Hippocratic, was taken by Dr Messenger Monsey, who lived at No. 5 Honey Hill. He was to become a physician at the Chelsea Royal Hospital in 1742 and had previously attended Elizabeth Felton, Lady of the Bed Chamber to Queen Caroline. Elizabeth was the second wife of John Hervey, 1st Earl of Bristol, and had their town house, the Manor House, designed by amateur architect James Burroughs. Hervey complained about his builder, William Steel, sleeping in with headaches from drinking too much tea and breaking his carts from overloading them. Elizabeth had numerous children during her years of marriage; a letter of 1737 to her husband concludes, 'I have here enclosed you Dr Monsey's letter, which mine was an answer to; they may both now be burnt if you please, and he with them!' Obviously my lady was somewhat displeased with the good doctor.

The Salvation Army came to Bury in 1887 when two sisters, Captain and Lieutenant Newton, held services for just over two years in a run-down building on the corner with

Honey Hill, 1985.

Carved pigs on St Mary's.

Sparhawk Street before moving to a purpose-built citadel in St John's Street. Opposite here is the south side of St Mary's parish church, arguably the third largest in the country. Just below the clerestory are carved stone heads of pigs, which act as conduit water spouts for water from the roof. Its magnificent interior has an outstanding hammer beam roof of a procession of angels, wonderful stained-glass west window – the largest such of any parish church – and a vibrant east window depicting the martyrdom of St Edmund. Along with the subdued grave of Mary Rose, Henry VIII's sister, who was buried here after the Dissolution, the Suffolk Regt Chapel and a poignant memorial to HMS *Birkenhead*, this church is a repository of Bury's past. Saint Denys' at No. 6 is a stone-fronted house, one of only two in Bury (Hanchets in King's Road is the other) and hides an ancient building from the fifteenth century. Residing here in 1721 was Arundel Coke, whose murderous attempt to deprive his brother-in-law Edward Crispe of his life and fortune ended with Coke going to the gallows. Saint Denys' later owner was Thomas Singleton, stonemason extraordinaire; he was responsible for this stone facade and the fine carvings on the Market Cross. The adjacent Georgian manor house is outstanding and was once home to the Herveys of Ickworth and the ill-fated Walter Guinness, 1st Baron Moyne, who was assassinated in Cairo in 1944. Until its closure in 2006, the Manor House Museum housed a fine costume and art collection and a fabulous myriad of timepieces bequeathed to the people of Bury by Frederic Gershom Parkington in memory of his son John, who was killed in the Second World War.

Hospital Road

Formerly known as Chevington Road, it had a change of name when the Suffolk General Hospital opened in January 1826, built on the site of a large weapons depot from Napoleonic times. This was the first real modern hospital in Suffolk; the great and the good of Bury and the surrounding district were very much involved. Over the years a great deal of expansion took place, including wooden huts used as wards and a fine extension in 1939 known as the Bristol Annexe. Architect Bill Mitchell was responsible for this; he later went on to draw up the plans for the Mildenhall Estate in 1946, having Mitchell Avenue named after him. After the hospital closed the annexe was renovated in 1981 and is now Cornwallis Court, a residential care home run by the Royal Masonic Benevolent Institution. Very little of the hospital site remains, and housing called St Peter's Court is there now. The nearby St Peter's Church was built in 1856–58 as a chapel of ease for St Mary's by Thomas Farrow, who had carried out repairs to the Norman Tower. St John's Church spire of 1842 probably inspired St Peter's architect John Hakewill. For many of its early years the secret financial benefactors that enabled the church to be built were unknown; eventually the three Misses Smith, daughters of Dr Thomas Smith, were unmasked. He was a physician at the hospital from its inception until his death in 1848. A foundation stone tells us that the site was provided by the Marquess of Bristol and that the Revd Charles Phipps Eyre and others were in attendance; Revd Eyre lent his name to Eyre Close, Out Westgate. St Peter's is now much more user friendly as comfortable chairs for the worshippers have replaced the pews. The adjacent St Peter's Infants School of 1876, now the Hyndman Centre, was a feeder school to the Guildhall Feoffment Junior School.

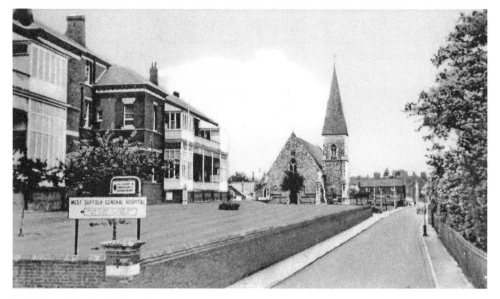

Looking to St Peter's Church.

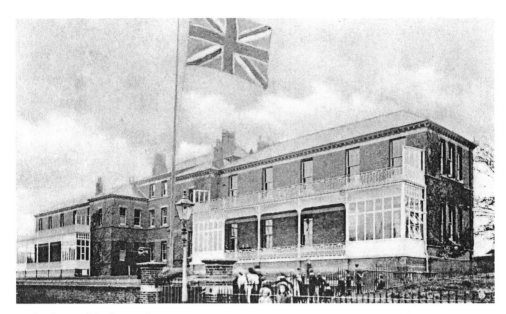

Early photo of the hospital.

Opposite the entrance to Cornwallis/St Peter's Court is the Child Development Centre. It was built as the Marjory Blyde Nurses Home on land given in memory of Oliver Denn Johnson of Barrow, chairman of West Suffolk County Council. He died in 1915, but it wasn't until 1924 that the project began with Harvey G. Frost as builder. HRH Princess Mary did the official opening. Miss Blyde, once matron of the hospital, went on to become matron of the prestigious King's College Hospital, London. Adjacent to the Cornwallis Court entrance is Union Terrace and No. 14 is the birthplace of author Louise De La Ramee in 1839. Her mother was English and her estranged father French, and likely she was raised by her grandmother. Her childhood pronunciation of her own name 'Ouida' led her to use it as a pen name after she realised she had a talent for writing, producing novels that were lapped up by Victorian society. She was an ardent pacifist, animal lover and spendthrift, living above her means in a London hotel. She eventually moved to Italy, where she died penniless in 1908. She despised her birthplace; part of a quote attributed to her was 'Why, the inhabitants are driven to ringing their own door bells lest they rust through lack of use.' Going past Petticoat Lane you will encounter former municipal buildings: ex-police and nurse's houses; the current ambulance depot, which was once part of a Civil Defence centre in use during the Cold War at the beginning of the 1960s; and Westgate Primary School. Riverwalk School for children with special needs is along further; the adjacent South Court residential unit is now demolished, and homes are under construction. You cannot leave Hospital Road without mention of its two pubs: the Dove and the Elephant & Castle. The Dove, now a CAMRA award-winning real ale hostelry, was built in 1836 as a beerhouse. The 'Trunk', as the Elephant and Castle was known, is alas no more; having closed in 2012, it is now an undertakers.

Ipswich Street

With the consecration of St John's Church in 1842, most of Long Brackland was renamed St John's Street. It was decided to create a street near the bottom to get better access to the railway station (opened 1846); the street's name was to be Ipswich Street in deference to the rail line from Ipswich. This area, along with the Tayfen, became a major industrial part of the town. With maltings, mills, gasworks, coal and railway yards, hard work often called for heavy drinking, and there were plenty of opportunities to do just that. In and around Ipswich Street there was the Red Lion at the corner of Peckham Street, and the Britannia at the corner of Long Brackland – alas, both are now gone. The last landlord of this no-nonsense pub was Eric Bull, who was associated with it for twenty-six years. The 'Brit', as it was affectionately known, was sold by Greene King in 1986 for around £65,000 to the Cyrenian Society. As a hostel for eight homeless residents, Britannia House opened but to some local opposition. The Red Lion, which opened in the mid-nineteenth century as a beerhouse, served its last beer in 1985 and is now a private house. The bracket for its old pub sign is still evident today. Further down the street were shops. At No. 7 Betty Woodward ran Station Stores for many years along with her husband Harry, aka John. Betty and her three sisters had previously worked at Warrell's Stores on Angel Hill, their father eventually joining them as a van driver. No. 11 was the wholefood premises of Butterworth & Son, who also specialised in blending tea. At the neighbouring business, Cornhill Stationers, an extension at the rear exposed what was thought to be part of Bury's ancient town wall, along with various shards of pottery and earthenware jars. The relatively modern Ipswich Terrace of today replaced twelve typical Victorian cottages swept away in the town's slum clearance of the 1960s and 1970s, which also enveloped much of Long Brackland.

A much-changed street.

J

Jacqueline Close

All that is left of this thirty-townhouse development are two properties close to Mill Road. The Hospital Management Board had turned down the opportunity to build on the site they owned to expand their nearby laundry; the land eventually went to auction whereby it was purchased by a London firm, Tricord Developments. The three-storey houses were built from 1964 onwards and were very desirable, costing between £3,950 and £4,500. The buyers thought they had a home for their future, but they were wrong These poor people were to lose not only their homes but their money as well because the land that the houses were built on had massive caverns beneath – chalk mines from at least the nineteenth century. Chalk was mined deep for the purity needed to burn in limekilns for many uses, including lime mortar. Local knowledge is a wonderful thing. Close by there are Limekiln Cottages, Chalk road, and on the Ordnance Survey maps which mention limekilns such as those owned by the Bullen family. Locals could even remember the chalk being mined in 1913. In normal circumstances, the dispersal of rainwater off the roof and into gutters, downpipes and finally soakaways is a standard good building practice and would have been fine, but this was not to be at Jacqueline Close. There was some subsidence in 1967, which was provisionally dealt with, however everything came to a head after several weeks of torrential rain in December 1968. Parts of the ceilings of the caverns some 35 feet below were washed away, resulting in the footings of some houses to give way. Evacuation followed and the local council temporarily rehoused the bewildered residents in newly built council houses on the Howard Estate. The Chelsea Speleological Society (study of caves) heard of the tragedy and offered to investigate at no cost. Their thorough survey detailed much of the tunnel system, a veritable warren as some of the tunnels are massive and cover nearly an acre. This bad news was followed by a public enquiry. In 1976, an environmental inspector, Mr Burton-Sibton, met with the residents. The outcome of this disgraceful affair was a compulsory purchase of the forlorn site a year later. Demolition of the houses was inevitable, but compensation was not forthcoming; the poor owners were angry and out of pocket. A solution was sought for the infilling of the cavernous holes; lorry loads of fly ash from the coal-fired Cliff Quay power station in Ipswich were used.

Transport costs were to be met by the homeowners but it was about as good as filling a holed bucket with water. Only two owners had subsidence insurance, which was fortunately paid out. Although the site now lies abandoned, incredibly it is included in Vision 31, the master plan of the future of Bury. Surely history could not repeat itself.

Above and below: Eldon Griffiths, MP for Bury, and demolition of the close.

K

King's Road

With the opening of the new borough cemetery in 1855 at the end of Field Lane, it was decided to rename the lane Cemetery Road. This was changed again in 1911 to King's Road in honour of the coronation of George V. King's Road has had a very eventful history and is now bisected by the inner relief road Parkway, which opened in 1978. Once there was a windmill and four public houses, including the short-lived Soldiers' Home, plying their trade; the mill and pubs are now gone. The Wheatsheaf beerhouse on the corner with Chalk Road only received its full licence in 1961 and closed twenty years later to become a hair salon with the very apt name the Mane Attraction; now it is called the Yellow House. From the nineteenth century, the Butchers Arms public house was a great favourite with Boby's workers due to its close proximity to their factory entrance. The Butchers closed in 1991. The Cricketers pub, which suffered demolition to allow Parkway to be built, was popular with the locals, especially when Bury Town FC were at home. The club, one of the oldest non-league sides in the country from 1874, was formed as the Bury St Edmund's Football Club at the Suffolk Hotel. They played their matches at the then-named Cricket Field, later known simply as the King's Road Ground. The record attendance at the ground was

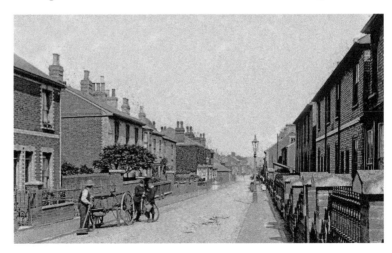

King's Road
around 1900.

when they played Cambridge Town in the Eastern Counties League in 1949 in front of 4,343 people. Perhaps their most successful side was in the early 1960s when they regularly attracted large crowds, with Frewers' bakery at the entrance to the ground doing a roaring trade in filled rolls for the fans. The last game played at King's Road was on 30 April 1976 against West Ham in front of 1,750 people, the score a creditable 2-2. The club subsequently relocated to Ram Meadow.

During the latter half of the nineteenth century, grocer Thomas Ridley lived at Linden House, Cemetery Road; in 1911 it was renumbered No. 147 King's Road. Thomas was mayor of Bury twice – in 1878 and 1882 – and was very much involved with the local Baptist church. During the twentieth century, his house became the offices of Anglian Water. Adjacent are cottages known as Salem Place, a name forever to be linked to witches; curiously, Salem is a shortened version of Jerusalem. On the corner with Mill Road was where Saunder's Fruit & Veg shop used to be, later becoming Gladys Lockwood's wool shop; her husband Ron was a local builder and had a yard to the rear. Opposite Victoria Street Hanchets once had their premises; the site is now awaiting development. Previously, they had been further down King's Road in a stone-fronted house, one of only two in the town. Arthur Hanchet & Co. had taken over the old Bury firm of De Carle Stonemasons around 1883. Hanchets were very busy around the turn of the twentieth century, putting up two Protestant memorials in the Great Churchyard and Whiting Street as well as recutting the five abbots' gravestone coffin lids in the Chapter House in the abbey gardens in 1903 at the cost of 1d per letter. Another shop that was relocated was that of L. P. Miller & Son, suppliers of carpets, rugs, vinyls and linos; they were known as the 'Lino Kings'. Their premises were demolished to make way for Parkway. Opposite Prospect Row the son, Peter Miller, reopened in new purpose-built premises on the site of a former school run by the National Society. Founded in 1811 for the purpose of educating the poor, the school was here for a short while during the early part of the nineteenth century. Thomas Reach of Southgate Street was among its first headmasters before the school moved to Risbygate Street. When Peter retired, his shop became a saddlery and pet store; later there was a complete change of use as it became the Co-operative Funeral Care. Opposite in what was the Bury Free Press (BFP) car park, John William Clarke had a photography studio in the late nineteenth century; he was the first commercial photographer in Bury St Edmunds. The BFP was started in 1817 by Thomas Lucia, who acquired this site in 1874. On his death, local solicitor Henry Bankes Ashton ran the paper for Lucia's trustees from the corner of Abbeygate and Guildhall Street until Henry persuaded press magnate Richard Winfrey to buy the BFP. He went on to expand it with his son Pat, eventually selling out to East Anglian Midland Press (EMAP), which in turn was acquired by Johnston Press. In April 1980, an arsonist set fire to the BFP building and many important archives were lost; the fire was one of several in the town that year. Over the years the staff decreased as technology increased. Many locals still fondly refer to the BFP as the 'Bury Bummer', from an era when it was cut into small squares for another purpose.

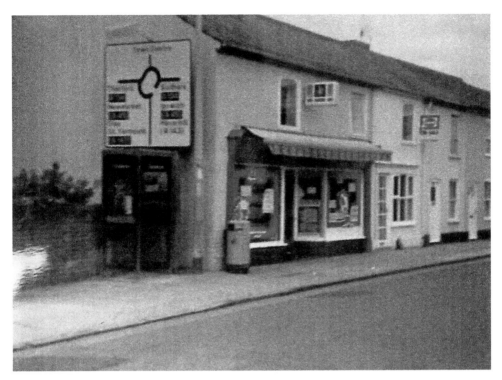

Sanders newsagents at No. 133.

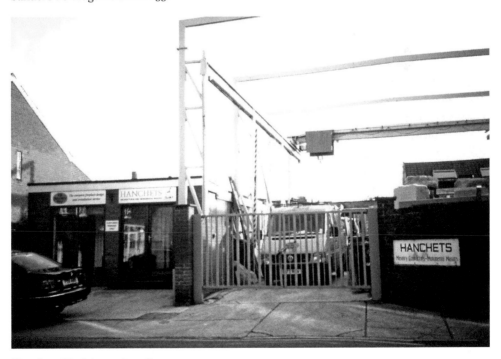

Hanchets Yard (now closed).

Klondyke

The Klondyke gold rush of 1896–99 in Yukon, Canada, was a stampede of over 100,000 prospectors after gold had been discovered in Bonanza Creek. A hastily constructed wooden town known today as Dawson City was to provide those few who struck it rich with all their needs. Despite the gold petering out, the final remnants lasting until 1903, there are still occasional forages into the area with modern equipment by miners, though tourists are more numerous. Klondyke in Bury St Edmunds was originally a row of sixteen Victorian terraced houses from 1899, some rendered, some brick, today accessed by vehicle via a partly potholed lane from Beeton's Way or by foot from what was the original access from Northgate Avenue. Local firm R. Boby Ltd had in 1899/1900 acquired 27 acres of land near Northgate railway station for the building of a foundry as their St Andrew's Works foundry was no longer large enough; the cottages were for some of their workers. Greene King purchased them off Charles Mumford in 1923, the former owner and nephew of Robert Boby. In 1924 there were at least sixty employees at work in the Northgate Foundry; Boby's themselves were one of the largest employers in the town. Boby's foundry closed in 1966; no trace of it remains other than scraps of scattered slag. There is also no evidence of the Second World War anti-aircraft gun emplacement that was once here. The large concrete base and metal plate it swivelled on has gone, probably under one of the playing fields of St Benedict and County Upper schools that now sandwich the Klondyke. No. 16 is the only property in the row with a cellar as it was built for the foundry foreman. A further house, No. 17, was added to the terrace in 1993.

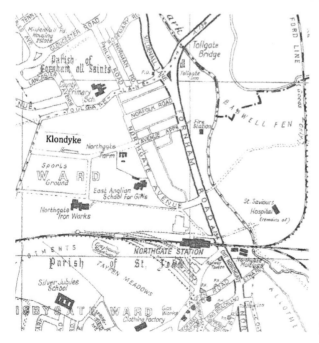

Klondyke, post-1953.

L

Langton Place

Langton Garage, no more than a large glorified shed, was owned by the Todd family; its 1969 advertisement stated there was parking capacity for 100 cars. It was sold in March 1982 and, with the purchase of No. 7 Whiting Street, the subsequent demolition allowed the creation of Langton Place, a throughway shopping precinct from Hatter Street to Whiting Street. During the site clearance and subsequent building works, a stone fireplace was found, a vestige of the former occupants when it was the Jewish quarter of medieval Bury. Local architects Heaton, Abbott and Swale were responsible for the modern scheme, and the whole complex was built by W. J. Baker Builders Ltd, once one of the largest builders in the area, alas no longer with us. There were fourteen

Langton Garage.

units originally with a mix of various retail and office businesses that opened in June 1987, costing £1.5 million. This shopping precinct is named after Archbishop Stephen Langton of Canterbury who was instrumental in the formation of Magna Carta. It is a connection of which Bury St Edmunds, a member of the Magna Carta Trust, is justly proud of. To celebrate the 800-year anniversary of the barons meeting in Bury and swearing an oath at St Edmund's Shrine, 2015 saw the Lincoln Magna Carta on show at the cathedral. Langton Place, with a selection of very desirable flats and apartments above the shop premises, is a very pleasant shopping area deserving more patronage as it far outshines Cornhill Walk.

Long Brackland

This street once ran all the way down from Brentgovel Street to Northgate Street, but with the building of St John's Church in 1841, part of the street was renamed St John's Street down as far as today's Ipswich Street. Brackland, meaning 'broken ground', had two parts: Long and Short (Little) land that was between the rivers Lark and Tay, the latter little more than a ditch now. Referred by locals at one time as the 'Borders', probably because it formed the border of the town, it was looked upon as one of the poorer areas of the town. Perhaps one of its most famous inhabitants was a monk of the abbey named Jocelin of Brakelond. He kept a chronicle of life at the abbey in the late twelfth and early thirteenth centuries. Little is known about Jocelin, but his account of life under the Benedictine Rule gives a real insight into monastic life at the time. Here in Long Brackland, at the heart of industrial Bury St Edmunds, life for the residents was very hard. The Salvation Army built their Citadel nearby in 1889 to administer to the poor, and poor they were. Large families were common and top and tailing in bed was the norm, as were shared outside taps and privies. A nocturnal visit to this unrefined earth closet was definitely only undertaken when desperation kicked in as your oil lamp or candle could be easily extinguished in the night air. With crowded accommodation came other problems such as diseases – scarlet fever and TB, fearful visitors that took no prisoners. One thing the old terraces had, now sadly lacking, was a community spirit. Everyone knew everybody else and their business as they were all in the same boat. Money was hard to come by, but it was looked upon as a working man's right to his pint as several pubs peppered the area. The King William IV (aka the 'King Billy') in Long Brackland was frequently used. It was said in later years before it came down that visiting darts teams never ate the sandwiches provided by their hosts, not because of their quality but it was probably the first square meal some of the locals had eaten that day. With the slum clearances of the 1960s, swathes of Victorian terrace houses were demolished throughout the town. An eminent Bury doctor, Dr Joyce Cockram, said it was the best thing that could have happened to them as they were a breeding ground for diseases. Then, as now, housing was very important; the major difference is that hygiene and facilities are required without question today. In the days of yesteryear no one knew any different.

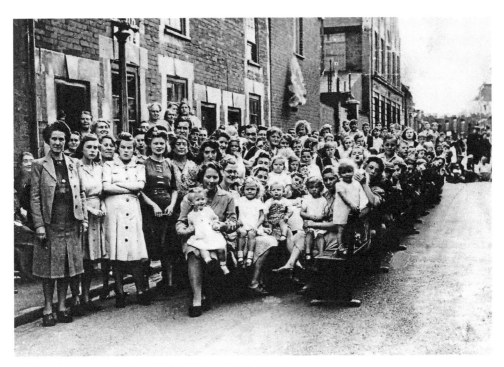

Celebrations to mark the end of the Second World War.

This building was once the home of Saxon Radio.

No. 50, Long Brackland was built in 1887 by Arthur Grimwood of Sudbury for Leonard Makin, a wholesale grocer. He supplied many of the small grocers in the town – no supermarkets back then! For many years during the twentieth century the building was used by the Co-operative Society and Pordages as a warehouse. There was a big change of use when it became the home of Saxon Radio, the town's first independent radio station, which opened in 1982; the station went on to become part of Suffolk Group Radio. The building was put up for sale in 2012 and advertised as having 5,200 square feet with an asking price of £600,000. Opposite here is No. 16, the former Seven Stars Inn which was rebuilt during the nineteenth century; it retained some of the timber frame hostelry from a century earlier. The oval stone plaque put up in 1907 above the doorway is to Victorian novelist Henry Cockton. His most famous novel was *The Adventures of Valentine Vox*. Henry was a reasonably successful writer of his time and his book sold thousands, but although he received payment from his publisher, he never retained the copyright, which was to have catastrophic consequences for him later. As a salesman on trips to Bury he stayed at the Seven Stars and eventually married the landlady's daughter, Ann Howes. One hare-brained scheme of his was when he heard a rumour that the next barley harvest would be poor and that there would be a repeal of the malt tax; he thought he could make a killing. Unfortunately for him neither happened, and the barley he had stockpiled in warehouses went mouldy. On top of this, he had stood as guarantor for his criminal brother who then absconded to Australia, leaving Henry £200 out of pocket. With his publisher going bankrupt things couldn't get worse – could they? But they did. His family rejected him and Henry worried himself into an early grave in 1853, aged just forty-six. The Seven Stars eventually closed in 1917, having not been economically viable for some time.

Cockton Plaque and Seven Stars Inn further down.

M

Maundy Close

Eight flats from the early 1930s fronting Out Westgate were demolished to allow thirty homes to go ahead, built by the Havebury Housing Partnership. Better usage of the large gardens at the rear of the old properties enabled this very green project to proceed; solar thermal panels provide 60 per cent of the hot water needs. The homes were opened in early 2010 and were aptly named Maundy Close in honour of Her Majesty Queen Elizabeth's visit to Bury in 2009 to present Maundy Money to 166 men and women. The people who were chosen were pensioners who had contributed to the community; they received the red-and-yellow purses containing the silver one, two, three and four pence coins at the service held in St Edmundsbury Cathedral. Afterwards, a civic reception was held in the Athenaeum for the royal party, and the recipients were given a dinner in a marquee on the cathedral cloister's garth. Surprisingly it was King John who created the service at Knaresborough in 1210 giving alms, vestments and altar cloths on the Thursday, and over the centuries the service has been modified to where we are with it now. Elizabeth II became Britain's longest-reigning monarch on 9 September 2015.

The Out Westgate flats on the right were demolished.

Maynewater Lane and Square

A large feudal barony, the Honour of Clare, one of the wealthiest in East Anglia, was granted by William the Conqueror to Richard, son of Count Gilbert de Brionne. In the medieval period this area of Bury was known as the Maydewater (the River Linnet aka Maidwater) part of the Honour, yet curiously within the town boundary known as the Banleuca. The 9th Lord of Clare, Gilbert de Clare, held land here and in nearby Friars Lane. The River Linnet often flooded, but dredging in recent years has minimised this problem. A dubious 1960s award-winning row of houses, built for police cadets, was to suffer from severe damp problems which would ultimately lead to the closure of the houses. They are now refurbished and looking far better than they ever did. Nearby was the Southgate Brewery, which in 1820 backed on to the Linnet. It was owned in 1855 by Henry Braddock, who also had a valuable portfolio of eleven public houses. When he died in 1868, Edward Greene purchased it for £7,000 to stop it falling into the hands of arch-rival Fred King. Edward promptly demolished it, and the barren site was used later on in the twentieth century as the Linnet Service Station; a new development called Regency Place is there now. On the corner with Southgate Street was Southbridge House, owned at one time by William Pead, manager of GK in the late nineteenth century. It was demolished to widen the corner into Maynewater Lane in 1970. The sixteen cottages of Maynewater Square were built by Edward Greene in 1868 for his brewery workers. Adjacent is Bath Cottage, so named because at its rear were the first public swimming baths in Bury, although they are now gone. The instigator of these in 1870 was Lot Jackaman, builder of the Corn Exchange and Bath Cottage, who supposedly had gleaned this idea after a visit to Germany.

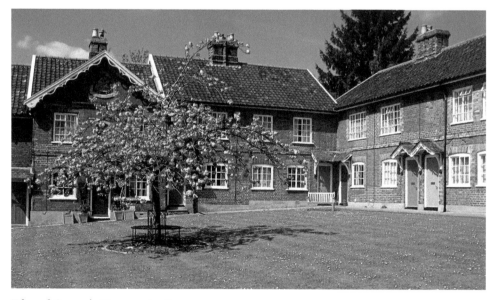

Edward Greene's Maynewater Square.

Mermaid Close

During the medieval period this area, off today's Fornham Road, was known as Maremayd Pitts; whether there were any mermaids ever seen here is part of Bury folklore; along with a tale of a lovesick girl who drowned herself. A story is also told of a mound among the pits known as Snake Island; according to legend, a boy stumbled across an adder's nest, was bitten and subsequently died. During monastic times, these pits had an abundance of fish, which were coveted by the abbot, fresh water springs being one of the reasons for their survival. In 1851 a report by the town's Paving Commissioners was published with the intention of tapping into the springs via a well for the town supply. However, this well-meaning scheme never took off because of the logistics of pumping the water from this low-lying terrain. In 1953 the Borough Fire Brigade with different pumps moved from The Shambles, Cornhill, where it had been since 1899. Its relocation to Fornham Road on the mermaid site meant a speedier response as the previous station was totally inadequate. Supposedly due to the instability of the ground the station was built on, it was decided to move yet again. On 23 March 1987, fifty firemen (no female firefighters then) and seven civilian staff lined up for a farewell photo shoot at the station before moving to a new purpose-built fire station in Parkway North. Three years after the station closed, twenty-eight flats and maisonettes were built – Mermaid Close.

The fire station, here since 1953.

Mill Road

Formerly known as Mill Lane, Mill Road ran from Field Lane (King's Road), 'kinking' just past the later ill-fated Jacqueline Close; here it was called Donkey Lane after the beasts of burden which carried the chalk from the mines; then it went on to meet Hospital Road at today's junction with Petticoat Lane. Nowadays Mill Road is split in two at Castle Road, the 'kink' is no more. Indelible links to the past are the Thingoe Union Workhouse, Zeppelin bombing raid, the windmill and the catastrophic chalk workings. The workhouse was built in 1836–37 by William Steggles junior to end up replacing the Bury Workhouse in College Street, which was sold off in 1884. The Mill Road 'Spike' went on to become St Mary's geriatric hospital until its demolition in 1979. In 1916, a Zeppelin dropped its deadly cargo on Nos 73 and 75, tragically resulting in the death of three members of the Durball family at No. 75 and Harry Frost at No. 73; many surrounding houses were also damaged. In 1955, plumber Percy Cook was working at Willow Cottages, one of fourteen cottages that were at right angles to Mill Road. He got a little more than he bargained for while working in the WC; he fell down a large 40-foot hole that suddenly appeared. He looked more than a little flushed as he was dragged out! Willow Cottages were named after a willow weaving industry shown on Payne's 1833 map of the town. In 2001, St Mary's Court was built on the Willow Cottages site. The mill, at arguably the highest part of the borough, had James Limmer as miller during the nineteenth century; his house on the corner of Castle Road is still there. James ended up being associated with two other mills in the area, including Spinton Mill in Field Lane. With the technical advances towards the end of the century, wind power was replaced by steamrollers. George King, on behalf of Burlinghams, acquired the mill in 1901 and it was demolished in 1914.

The miller's house.

The Suffolk Regiment homes.

Minden Close

Minden Close is sandwiched between The Vinefields and Eastgate Street. In 1831, the 2nd Marquess of Bristol Frederick Hervey employed Nathaniel Hodson to lay out formal gardens on the abbey's site, then owned by the Hervey family. This ownership extended to part of the Vinefields and to the Keepers Cottage at No. 141 Eastgate Street, built on his behalf in 1862. In 1906, Rear Admiral Frederick Fane Hervey, later 4th Marquess of Bristol, became MP for Bury, but on the death of his uncle a year later, he took up his seat in the House of Lords. In February 1951, he gave land to build four one-bedroom flats and four one-bedroom bungalows for the Suffolk Regiment. He was to die just eight months later after his generous gift. Minden Close was named after the famous battle in Westphalia, Germany, on 1 August 1759, when a combined force of British, Hanoverian, Prussian and Hessian soldiers defeated the French Army during the Seven Years' War. The six infantry divisions of Britain included the 12th Regiment of Foot, later to become the Suffolk Regiment. Though now part of the Royal Anglian Regiment, Minden will be forever enshrined in their annals. Minden Day is still celebrated today after soldiers plucked red and yellow roses and put them in their hats for good luck on that glorious day when the infantry routed the French cavalry. These Suffolk Regimental Homes were taken over in 2002 by Haig Homes, a charitable trust founded in 1929 as a memorial to Field Marshall Haig to provide housing for ex-servicemen. Through its sister charity, Haig Housing Trust, they manage over 1,300 properties throughout the United Kingdom for forty-seven local authorities.

Northgate Street

From early times this street was known as the High Street and ran from the North Gate across the west front of the abbey to Sparhawk Street. The North Gate, where the roundabout is today, was pulled down in the 1760s to allow for easier access. The interchange/roundabout for the A14, which was completed by 1974, meant that several old shops were pulled down, such as Hobson's Game Dealers, Stebbing's Bakery, Northgate Street Post Office and the former Three Horseshoes public house, which had its last pint pulled in 1934. These were a major loss to the town for the sake of the town's expansion. Another loss in 1997 was the New Inn, so called because

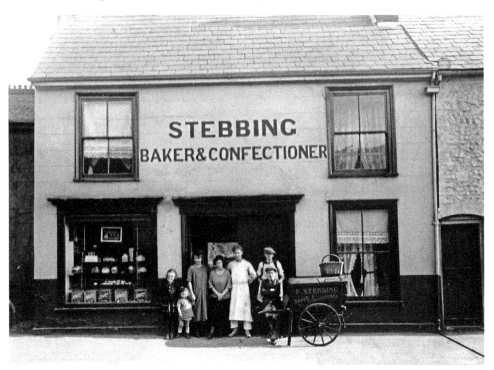

Stebbing's bakery at No. 73.

A car-free street!

it was the first purpose-built pub in Bury when it opened in 1863. Another inn no longer with us is the Globe; it was on the corner with Angel Hill. As the Cock & Pye, this dilapidated inn was purchased by Francis Clark in 1836 and renamed. He also did an exchange with some property he owned in Northgate Street with the executors of the Jacob Johnson Charity, which owned two houses in Looms Lane at the rear of The Globe. His intention was to make this a well-used coaching inn; unfortunately for him, the railways came to Bury in 1846 and he was declared bankrupt two years later. The Globe was demolished, and a new property was built by Henry Reed of Reeds Buildings fame just off Northgate Street. The corner of Looms Lane, near to where Clark was to have his stabling, had an Independent chapel which it became a Congregational church after a revamp in 1866 and a Primitive Methodist chapel from 1902 to 1934. During part of the twentieth century, it was known as the Victory Chapel and has been used for several commercial purposes since.

Bury Grammar School was founded in 1550 in Eastgate Street, but in 1665 it moved to Northgate Street; the building is today's St Michael's Close. There is an inscription here in Latin telling of the move, plus a niche that once supposedly held a statue of the grammar school founder, Edward VI. In 1883, the school moved to The Vinefields, and St Michael's Close became a high school for girls for a period of time; it is now divided into flats. Two other schools had their origins in Northgate Street. One was the East Anglian Wesleyan Methodist School which opened in January 1881, later moving to an 11-acre site in Northgate Avenue and in 1935 this 'boys only' school moved to Culford. The West Suffolk County School was founded in 1902 and located in a large red-brick building, which had for a short period been the Falconbury School; an extension was added in 1907. In 1964 this school moved to Beetons Way and became the County Upper School.

In 1915, a Zeppelin attacked Bury, dropping a bomb on the Anchor Inn, which then stood opposite Looms Lane. The roof was fire damaged, and it would seem that it was the final nail in the coffin of this beerhouse. Rather dreary flats are here now, but this street has a fair selection of quality buildings, such as St Olaves and Manson House residential home, along with the Victorian villas. Though not of the same architectural merit, the eight almshouses called Long Row, built in 1912 for the Guildhall Feoffment Trust, do have a community feel about them.

On the corner of Looms Lane, a jettied house was demolished in the road-widening scheme of the 1960s, which went a long way in alleviating congestion. The fine restoration of the neighbouring No. 7 uncovered medieval wall paintings relating to angels and an undertaker's bier in the cellar. But it is No. 8 Northgate House that rightly lays claim to being one of the finest houses in Bury. Parts of the interior harkens back to medieval times when it was two houses. With the coming of the eighteenth century it was owned by Major Richardson Pack, who was notoriously responsible for pulling down the abbot's palace in the Abbey Gardens. Thomas Evans, recorder at Bury, also lived at Northgate House; the Evans family owned it between 1745 and 1811 and carried out improvements, retaining the Jacobean ceilings and early Georgian features and creating the facade we know today. Banker Algernon Beckford Bevan lived here in 1900; he was manager and a director of the Capital and Counties bank in Buttermarket, which became Lloyds bank in 1919. However, the most famous owner of Northgate House, from 1955 until her death in 1983, was undoubtedly the celebrated author Norah Lofts. She mostly wrote historical novels, some loosely based on Bury St Edmunds, and adored her home, which has seen a blue plaque to her memory put on in 2012. Another fine house is No. 10, the Farmers Club from 1947. The house has origins that go right back to the fourteenth century when it was possibly three houses. During the period from 1662–89, the Hearth Tax returns show the house listed as having seventeen hearths. The Gages of Hengrave Hall were prominent owners of this house at one time when it was used as their town residence. In the mists of time it was also known as the Panels. The Leathes family included an MP among their tribe and lived here from 1761 until 1823. It is possible that during their period of occupation a brick skin was put on to their house, which happened to many timber-framed properties in the town. From the mid-nineteenth century, members of the Greene dynasty owned No. 10. It was John Wollaston Greene who sold the house in 1947. The family law firm of Greene & Greene is still in existence today as is the Farmers Club, whose membership now extends beyond the farming community.

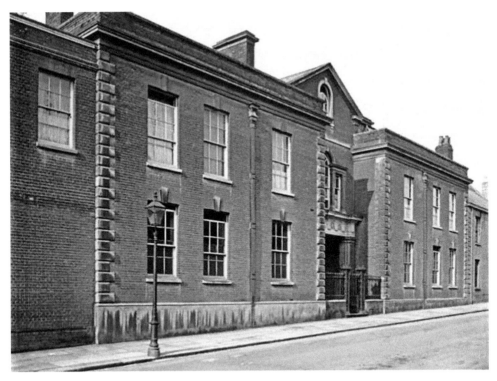

Above: Northgate House.
Below: The Victoria Laundry carnival float outside No. 112.

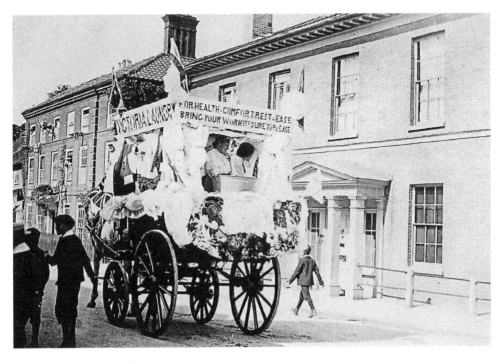

Out Risbygate

Out Risbygate means outside of the Risbygate; it stood where the Grapes Inn is. Today it starts at No. 1 St Georges Terrace, where a private school was run in the 1920s and 1930s by sisters Florrie, Gurtie and Nellie Smith; the entrance was via a doorway in Victoria Street (now bricked up). Opposite, but not far away, is a large crater known as St Peter's Pit, where hundreds of years ago chalk was mined for lime; it now makes for wonderful tobogganing in winter. Overlooking this is the West Suffolk College part of University Campus Suffolk, originating as a technical college at the Silver Jubilee School and moving here in 1959. Over the years, 'the Tech' has expanded and now runs a huge variety of successful courses. The uninspiring facade had an impressive makeover in 2014 with the architects Pick Everard receiving an award. On the college frontage sits the 'plague stone'. This much-moved base of one of the town's boundary crosses is now utilised as a planter but was once thought to have been used by people as a receptacle to sterilise money by soaking coins in vinegar before entering the town. Opposite here in the abbacy of Abbot Anselm (1121–1148) is a hospice known as St Peter's Hospital, which was founded for the care of ill and infirm priests. It would go on to house and care for lepers or 'lazars' as they were known in medieval times. With the Dissolution of the Monasteries in 1539 all religious houses were subject to examination by Henry VIII's commissioners; they were not guaranteed to survive,

UCS, once the tech college.

Prince Christian Memorial Homes.

even if they carried out good works as St Peter's did, and it was dissolved. Later, a stone barn was built here called St Peter's Barn. At different times, when building work was carried out, vestiges of the old hospital have been discovered including occupied graves, possibly of past inmates. Appropriately, the site now has a residential care home on it.

Bury St Edmunds was once a garrison town; people can still remember the rivalry between the 'squaddies' and the locals. The barracks was the home of the Suffolk Regiment until 1959, when they became part of the Royal Anglian Regiment. It was built in 1878 on a 20-acre site. St Peter's Barn Farm was purchased by the War Department from its owners; the trustees of the King Edward VI Grammar School. The architect was Major Seddon of the Royal Engineers, who designed accommodation for 250 men and some married quarters. There were up-to-date facilities for the time: a canteen, gym, reading room and a hospital. The most outstanding feature is the impressive keep. It is now Grade II listed and houses the regimental museum which was founded in 1935, three years before this military site was renamed the Gibraltar Barracks in honour of the Suffolk Regiments's heroic defence of the rock from 1779–83. What is left of the parade ground still hosts the annual Battle of Minden Day, the Suffolk's major honour. Some of the curtain walls remain, although are breached in places for access to the adjacent college ancillary departments. Two red-brick cottages, now known as the Suffolk Regiment Cottage Homes, were built opposite the Barrack(s) by subscription in memory of the officers and men of the Suffolk Regiment who lost their lives in South Africa between 1899 and 1902. They also commemorate Prince Christian Victor of Schleswig-Holstein, a favourite grandson of Queen Victoria, who died aged thirty-three in South Africa in 1900 from typhoid while in the Army. The building was completed in 1903 and was officially opened on 12 April 1904 by HRH Princess Christian of Schleswig-Holstein, third daughter of Queen Victoria and founder in 1907 of the Princess Christian's Army Nursing Reserves. The cottages were taken over by Haig Homes, a housing association, in 2002.

Old Dairy Yard

This is the only surviving wing of the Bury Workhouse, which opened in 1747. In 1807, prominent corporation member James Oakes declared that out of a town population of 7,500 there were around 4,500 paupers. This astonishing claim was brought about by the decline of the wool trade and the Napoleonic Wars. A set of rules were laid out for the inmates by the master and mistress of the workhouse and expected to be rigidly followed; diet was poor, quantities of food minimal. This institution was no hotel; any length of stay was not to be encouraged. Segregation of the sexes was a matter of course, though young children were kept with their mothers. Those of a young age were put to unpicking ropes to obtain oakum, which was mixed with tar to caulk ships o' the line. Children were taught the basics, apprentices were offered to local businesses and adults engaged on mundane tasks, while at every step costs were closely monitored. It closed in 1880 and most of it was sold off at auction in 1884 by Henry Lacy Scott. This part of the workhouse became the Nowton Lodge Dairy for much of the twentieth century (hence the current name); floats with their horses were stabled here. However, after it closed the building fell into disrepair, and there were talks of demolition. Local builder and decorator Ricky Beaumont, a Polish airman in Second World War, became the new owner and subsequently applied for demolition but failed as the building had been listed in 1972. An application to convert the building into houses led to local builder and new owner John George to carry out a successful conversion; Old Dairy Yard received an award from the Bury Society in 2009.

Former wing of the Bury Workhouse.

P

Pea Porridge Green

This part of the town, at the junction of Church Row and Cannon Street, is shown on Warren's eighteenth-century map of the town as Pease Porridge Green (also listed in Barnett's modern-day street atlas), with the 's' in Pease deliciously looking like an 'f'. The savoury dish pease porridge is more of a northern dish, similar to pottage and consisting of split yellow peas, boiled legumes and ham or bacon; while the traditional children's nursery rhyme 'Pease Porridge Hot' is accompanied by a clapping game. A row of six houses, Nos 28 to 33 Cannon Place, now overlooks what was once the Green. The Suffolk white-brick place was built by William Steggles & Son (also William) in 1825; plaques at either end testify to this, also that William Snr was seventy-nine when he died in 1834. Steggles & Son were major builders of the nineteenth century and responsible for low-cost housing but also municipal works such as the Thingoe Union Workhouse and Eastgate Bridge by William Jr. At No. 33 Church Row end is a redundant shop, and at No. 28 are the former premises of Joseph Frewer and his son, bakers and confectioners. When this ceased as a bakery it became a very good vegetarian restaurant, The Chalice. This was followed by two short-lived restaurants, Mamma Roma and Tiramisu, before reverting back to its original name and new owners for a time. The arrival of the current owners, Justin and Jurga Sharp, in 2009 heralded a

Bury Motorcycle Club.

new beginning for Bury's 'foodies'; their aptly named Pea Porridge restaurant is one of the town's finest; a recent makeover still incorporates Mr Frewer's oven, though only as an unused attraction. A ginkgo biloba tree planted in 2011 opposite the Old Cannon Brewery by the Bury Society to celebrate their fortieth anniversary is now growing in the parking area – a welcome addition to what was once was the Green.

Peckham Street

A flint cottage of some age, No. 40 is on the south side of this street. A recent development of nine properties called Old Stable Yard is at the rear, on the site of old garages. However, most of the street is terraced housing, in fact the north side is one long red-brick terrace save for two alleyways for rear access, which is because at the rear was a rope-walk. This was a long, covered way where lengths of jute or hemp were twisted under tension, creating ropes of different plys. The walk was owned by Frederick Peckham, who lived at No. 22, the street being built in the 1860s or 1870s and was initially called Peckham Row, then Peckham Walk; Peckham was still advertising as a rope-maker in 1908. William Peckham, a relative, was living at No. 17 and advertised his business as a rope, twine and sacking cloth manufacturer; he was also landlord of the Star Inn, Mustow Street. Just before the north corner with Ipswich Street there was a ragged school for the poor, built in 1866 and run by a charity for the education of destitute children. It existed for quite a few years as a Mrs Creek was schoolmistress in 1927; modern flats are now on the site. In the same year the school came into being so did the Bury Permanent Building Society; they were to invest in the purchase of five of the Peckham Street houses, as did a Mr Tunbridge who bought six and a Mr Head who bought three. On the southern corner with Ipswich Street stood the Red Lion pub, its yard stretching up Peckham Street where there is a mix of Suffolk white- and red-brick terraced homes. When the rope-walk finished is unknown, but during the early 1970s local builders Rampling and Walker built several flat roof extensions at the rear of the properties.

Spalding rope-walk similar to Bury.

Coronation
celebrations.

Priors Avenue

The Priors Estate was initially known as the Perry Barn Estate. Building work started in 1927 and it is often referred to as Hill 60 after a First World War battleground in which the 4th battalion of the Suffolk Regiment fought above the town of Ypres in Belgium. The hill was supposedly 60 metres above sea level. As a major piece of tactical ground it was held by German and Allied forces at different times. But the hill was not natural, it was a gigantic spoil heap made from the diggings of the local railway. During the heavy fighting, the terrain was reduced to a muddy bog by torrential rain. The weather in the late 1920s in England was some of the wettest for years, so this was most probably where the Hill 60 nickname came from. On the corner with West Road was the Priors Inn, the largest pub in the town at the time. It opened in 1933 and the licence was transferred from the recently closed Horse & Groom in St Andrew's Street South. It was built by H. G. Frost to designs by architect Bill Mitchell and the first landlord was Fred Staveley, but later landlords included former Bury town footballer Jack Hays and colourful mine hosts Bob and Jan Hitchings. The traditional 'pub outing' was much supported in its early years. However, nothing lasts forever and, in January 2014, the Priors closed due to market forces; demolition followed, with Havebury Housing Association building thirty-three properties called Britten Place and Perry Barn Close on the large site by 2016. Another earlier loss of a local amenity was Priors Stores at No. 9 Avenue House. In its early days it was run by Mr and Mrs Dennis then Mr and Mrs Deeks, and when they retired Arthur and Tricia Kemp took over until finally they did the same; it is now a private house. At No. 20, a bungalow purposefully for disabled people was built in 1987 with up-to-date equipment; at the time it was the first of its kind in East Anglia.

Prospect Row

Richard Payne's survey of the town in 1823 shows Prospect Row; did the use of 'prospect' in this context mean 'vista' or 'view'? With Woolhall Street being created in 1828, expansion was ripe for land off Field Lane. William Brown, a victualler, had also built properties in this area, called Brown's Close. One continuous line of terraced housing in Prospect Row was on the western side, but opposite a public house dominated the street line, the Duke of Wellington at No. 37, from the 1840s until it closed in 1986. It had a rival for some of that time at No. 39, the Crown and Anchor, which had stabling to the rear; it closed in 1906. The Duke, no longer a pub, reopened as the Jean Corke Day Centre for West Suffolk Mind Charity and Volunteer Bureau. Jean was the wife of Martin Corke, the grandson of Edward Lake, both of whom were managing directors of Greene King. Martin was a keen cricketer, and he and Jean were great supporters of the NHS and the Theatre Royal, especially in its restoration. Jean sadly died in 1980 and the ex-pub was demolished and in its stead a large block of flats was built. Once this street echoed to the sound of corporation dust carts as they made their way to the rubbish incinerators on the Playfields; the generators powered by the waste created electricity for the town. During August 1943, a double agent, John Moe, set limpet mines across condensers here, the subsequent explosions confirming his worth as a spy. Although the incident was reported, the truth was not revealed until many years later. Some of the names in the row, such as Electric Cottages and Waterworks Cottages, reflected the work carried out there. When the Council Depot moved up to Western Way in 1987, the site, a 'temporary' car park, was not surfaced properly until 1995. Prospect Row is now an access road to Debenhams with its ultra-modern design store on the the Arc shopping development, which is on the former site of Bury's cattle market.

Debenhams – an alien craft?

Queens Close

Halfway up Queens Road on the north side of the road are flats that are numbered from 99 to 104 and houses from 105 to 110. These properties are built on the site of an old people's home called Queens Close (1965), previously the site of fifteen post-Second World War corrugated asbestos-type prefabs that were erected soon after the war as a solution to the housing shortage. Bury resident Derek Bluett worked on

Above and below:
Temporary homes.

them just after the war. He said, 'First a base was prepared then two lorries would turn up with all the components for a new home, a fridge as well; we would put it all together in a day!' Other areas in the town had prefabs – York Close, East Close and Perry Close – making sixty-five homes in all. Originally intended as a stopgap measure of ten years, they went well past their sell-by date, damp and mould were the commonest complaints. Nationally thousands were erected under the Housing (Temporary Accommodation) Act 1944. The demolition of the council-run Queens Close led to a new development in 2008 by Havebury Partnership, a non-profit housing association, which was established in 2002 with over 6,000 properties in stock.

Queens Road

Bury St Edmunds town council met on 3 May 1887 and agreed to rename the existing Upper Brown Road to Queens Road in honour of Queen Victoria's Golden Jubilee on 20 June, so on the next day Queens Road came into existence and Lower Brown Road became York Road. The 'Brown' element came from George Brown of Tostock Place, Tostock. He was a bit of a lad when young, and while in the Army, he eloped with the daughter of wealthy James Crowe of Lakenham, Norwich, when she was at school in the city. On leaving the Army, George formed a bank in 1801 known as the Suffolk and Essex Bank with his father-in-law and brother-in law James Sparrow, who had married his wife's sister Ann. Their premises were those of the former Spink and Carss' bank in Buttermarket, which had gone bust. As the managing partner, Brown lived here until 1812, when he built Tostock Place, with an estate befitting his standing in the area. As was common in those days, he had the road diverted in order to do this – it is known as New Road today. Later, the bank was joined by two other notable families, the Bevans and Oakes. That business in Buttermarket eventually became Lloyds Bank in 1919. As an astute businessman he

Tostock Place.

bought several properties and, no doubt, land. In 1855, the borough purchased from the executors of his will in 1838 over 11 acres of land at the end of Field Lane for £2,276 in order to create the new cemetery. This was because the Great Churchyard had been closed, as were many others, by an Act of Parliament that prohibited graveyards in urban areas. Subsequently, the borough purchased more nearby land known as the Westfield Estate; it was sold off in large individual plots with lengthy gardens in some cases, and building started in the 1880s.

Still a very desirable part of the town to live, many of the properties have been extended over the years, though Queens Road suffers from that modern street scourge – parking. The Victorians and Edwardians had no need for off-road parking as cars were a rarity. Some tradesmen lived in the houses they constructed; for instance, builder and carpenter George Barbrooke built Nos 8 and 9 but left a gap between them (now filled in) so he could store his ladders. He was also responsible for No. 10 in 1886. The clerk Henry Hinnels lived here in 1907; he had obtained a mortgage of £425 from the trustees of the Royal Oddfellows Pride Lodge, quite a sum of money then, though nothing like the value nowadays. It passed into the ownership of Godfrey and Mable Hinnels in 1955 and, when she died in 1975, the house was put on the market. Adjacent to this property, with its 130-foot-long garden, is a small track with an old brick-and-flint barn that was thought to be a dairy at one time. It has now been successfully converted into dwellings. At the top of this track horses used to be kept in a meadow sandwiched between the cemetery and Queens Road. Further along, part of No. 23 was removed to allow access to a small development on the meadow, now called Cherry Tree Close. Up the road at the rear of No. 43, where the coal, coke and wood yards of S. Frewer were, there was just sufficient gap between him and his neighbour at No. 44 to trade. This was built in 1887 and was later to become the grocery and provisions store of Alfred Howlett, then Queens Road Post Office. Alfred's son Brian ran it until it sadly it closed on 18 June 2003.

The old Post Office.

Risbygate Street

The Risbygate Ward in medieval Bury was the most populated and affluent area of the town as it included the Great Market (today's Cornhill). Risbygate Street was to become a suburb and has seen many changes over the years; a notable loss is that of several buildings including pubs and several reinventions: the Wagon became the Market Tavern, then Bar 3 and is now, in 2016, the Gym – phew! One business that has grown over the years is that of C. J. Bowers & Son. This motorcycle company has traded in Risbygate Street since 1928 and is still going strong, as is its near neighbour, Lacy Scott & Knight, estate agents and auctioneers. Henry Lacy Scott started his auctioneer and valuation business in 1869, progressing to running a livestock market from 1874. Bury's cattle market had moved from the Beast Market on Cornhill in 1828 to St Andrew's Street South. A further access point to the cattle market was made off Risbygate Street in August 1852, and was officially opened by the mayor J. P. Everard. The cattle market site eventually became the Arc. The ancient Rising Sun was converted to a gastropub called the St Edmunds Tavern, for a short while (a tremendous loss to devotees of real pubs) but is now the Casa Del Mar restaurant. A baker and flour dealer, William Limmer, was at No. 91 near the Rising Sun; he had established his business in Bury in 1819, having come from Attleborough. His son James was a miller in Mill Road. Opposite and on the corner with Nelson Road was St James National School, this Gothic-style building, by Mr Barry from Liverpool and J. Johnson of Bury, was built in 1854. The school was demolished in 1937 to become a car park when St Edmundsbury School in Grove Road was opened. Havebury Housing have recently built a fine development of flats on this site. Another change of use is where the twentieth-century Brahams Scrap yard offices at No. 90 was; they had taken over the Clarkes Risbygate Brewery. The heavily timbered and jettied building, once two houses, have sixteenth- or seventeenth-century interiors, but I am sure the frontage has made full use of existing timbers in a twentieth-century makeover as its condition is too symmetrical. Greene King purchased the Clarke family-owned brewery in 1917, along with a valuable portfolio of inns and pubs that included the Cupola. Two demolished pubs were the Hare & Hounds and the Chequers Inn, which closed in 1974 to make way for Parkway. The Falcon, established in Victorian times, closed in 2012 but subsequently had a fine

residential conversion. A medieval leper hospital once stood where the B&Q superstore is today at the corner of Chalk Road, and this road was known as Spittle House Lane at one time – 'Spittle' is a shortened version of hospital. The priest Sir John Frenze endowed four houses here in 1494, and on this same corner George Cornish was to start his own engineering business, the Risbygate Foundry, in 1865 after working for Boby's. He was mayor of Bury in 1891 and died in 1897, his firm evolving into Cornish & Lloyds two years later. Though never a big employer like Boby's, it traded throughout the twentieth century, moving up to Northern Way, which is where it closed in 1972.

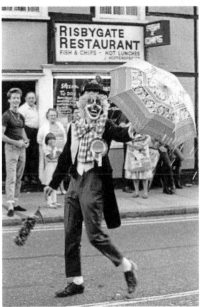

Above and below: The Rising Sun /
Mr Hopfensberger's Risbygate Restaurant.

King Raedwald's helmet in the British Museum.

Raedwald Drive

I am sure everyone has heard of Sutton Hoo near Woodbridge where the seventh-century ship burial of King Raedwald of East Anglia yielded a fabulous treasure now housed in the British Museum. The ship was excavated by Basil Brown in 1939 for owner Mrs Pretty, who generously gave the goods and treasure found in the grave to the nation. Raedwald's stepson, the pious Sigeberht, founded a Royal Ville and monastery at Beodericsworth, which ultimately became Bury St Edmunds. Raedwald Drive is part of a sprawling housing and commercial estate which takes its name from the large house (now a school) in Mount Road, Moreton Hall. It was built in 1773 for Professor Symonds of Cambridge University when it was known as St Edmunds Hill. With 140 acres of land released by the borough, the first dwellings on the estate were Bederic and Oswyn Close, containing mostly self-built individual homes. Further up, Raedwald Drive was mainly constructed by M&A Contractors of Chelmsford and Barratt Homes. They had taken over H. C. Janes of Luton in 1976, who built a major part of the Westley Road estate, off Fleming Road. From 1979 onwards, 197 properties with prices ranging from £19,300 to £37,500 were to become homes for Bury people and newcomers alike. Barratt's exceptional site foreman was one time Bury Golf Club Captain Tommy Bird, who also played for Bury Town FC in the 1950s. Timber-frame designs were used with brick skins; local suppliers of these frames, Marlow & Co. Ltd, were doing nice business with building firms when they were hit by a major setback in 1984. A television programme *World in Action* criticised the storage of the frames on some sites, the consequence of which was an immediate cessation of their usage.

S

Sparhawk Street

Whether this is a corruption of sparrowhawk is a matter of conjecture, but it is mentioned as Sparhawk Street from as far back as 1295. In 1910/11, No. 7 was a home for missionaries' children until it moved to Norman House in Guildhall Street; there was also a school in the street, St Mary's Parochial Girls and Infants school from 1842. No. 8, the Chantry Hotel, had connections at one time to the De Carle family, well-known stonemasons of the town. There are several wall plaques pertaining to their memory here. At one time a short-lived inn called the Chaise & Pair was in the street, the name reflecting that once-popular mode of transport. Much later, a more modern form was that of the internal combustion engine in the garage premises of Vic Brewster at No. 10, one of the earliest in the town. Vic was born at Stanstead near Clare and trained as a motor engineer at Colchester before coming to Bury; because of his reserved occupation he was exempted from duty during the First World War. He had fuel pumps put in that sold Cleveland petrol, a fuel blend of alcohol, ethanol and refined petrol; Cleveland were taken over by Esso in 1951. Vic and his wife 'Lil' were married for seventy-four years. Their association with the street was acknowledged when a new house built on that site was given the name 'Brewsters'. A tale relating

The author on the right – somewhat younger!

to the building of this house was how an 'old boy' would walk by every day while the site was being cleared and prepared. In a broad Suffolk accent he would ask the most mundane questions of the workers there, eventually getting on their 'wick'. On almost their last day on site they were going to give him some advice on where to go, but when he turned up he said, 'This was a garage you know, I worked here once, would you like to know where them petrol tanks were?' 'Come on, old friend!' was their joyful reply.

Southgate Street

When you look at an old map of the town, this street is out on a limb, a suburb of the town. This is because the South Gate was where today's Southgate Green is. Nearby was St Petronella's Hospital, which dates from around the twelfth century and was mainly for the treatment of female lepers. Its large tracery window was removed by Phillip Bennet of Rougham to the ruins of St Nicholas Hospital at the junction of Hollow Road and Barton Road early in the nineteenth century. Nothing of St Petronella's exists now, nor do any shops or public houses in the street. There were once six pubs, all now gone; the last to go was the Sword in Hand which used to have popular jazz evenings; opposite is the former Plough Inn. A mix of shops and businesses have all disappeared; White's directory of 1874 lists three bootmakers, three butchers, five assorted shopkeepers, three milliners and a tobacconist. This is without a tannery, cooper and a blacksmith! In the late twentieth century a post office closed. On the site of the vacated builder's merchants Watsons, aka William Brown, aka Jewsons the development of Sextons Meadows was built by Redrow Homes. Many businesses have disappeared from what once was a thriving trading community; homes are now strictly *de rigueur*. On the site of the old S & S flooring centre on the corner of Bakers Lane, new townhouses have been built. The old steam mill of Henry

Several builders merchants traded from here.

Cooke went several years ago, and the vets Swayne & Partners and the Pine Shop closed in 2015 and it even looks like the Ministry of Agriculture, Fisheries and Food is going over to residential in one form or another.

As we have already seen, the street has changed beyond recognition. Behind the scene, though, there are many gems to be found, such as the hidden thirteenth-century stone bridge that is over the Linnet, identified in Samuel Tymms's nineteenth-century book on Bury. The nearby Abbey Hotel, once the White Hart, has ancient timbers and abbey stone within; next door at No. 16, limestone masonry has been discovered – a vestige of the medieval St Botolphs Chapel that once stood here. At No. 80, aka Weavers Rest, there is a wealth of beams and jetties from the late fifteenth century, contributing to its Grade II* status. The facade on Linnet House at No. 32 hides an aged interior; it was once the home of Henry Crabb Robinson, diarist and the first war correspondent, who covered the Peninsular War. A stone oval plaque from 1907 is affixed to the building. The Guildhall Feoffment, major landowners in the town, had ten almshouses built by William Steggles in 1811, known as Long Row today. There were several other courts and yards off Southgate Street, Lion and Crown Court, Aberdeen Place and Bridges Yard – all now gone; the most likely the reason was the quality of the accommodation within. A small new development called Haberdon Place can be found to the rear of the former Sword in Hand pub. Other pubs to close were the Three Crowns at No. 7 in 1932 and the King of Prussia, on the corner of Prussia Lane. During the First World War, it had a name change to the Lord Kitchener due to vehement anti-German feelings; bizarrely, the lane suffered from Zeppelin bombing in 1916. The pub was closed in 1919 along with several other major Greene King austerity cutbacks – nothing new! Nearby stood the Jolly Toper which closed in 1908 (a toper being a drunkard); Toper Lane is now accessed from Raingate Street.

The White Hart, badge of Richard II.

Construction of the bus station is underway.

St Andrew's Street North

The west side of this street from its junction with Risbygate Street is somewhat muddling until it reaches Bishops Road when Victorian housing ensues. Once tree-lined, the street is now denuded of foliage. No. 1 St Andrew's Street North was the premises of Cash Cycle stores in the early part of the twentieth century; the premises were demolished in the 1960s and Hardys opened a carpet and furniture store in the replacement boring building, which is now a bookmakers. No. 2b is somewhat unusual as a business premises – it is underground! Jimmy Mitchell had his fabric and curtain company Burnett James here and completely renovated the extensive cellars. Jimmy used to be an England roller hockey player, Bury's Rollerbury on Station Hill was once a favourite Bury pastime until it closed in 2001. Jimmy's shop became Tony's Barbers and, when he retired from his eponymous shop after twenty-eight years, his son Adrian Doe reopened as Adies. Another building from the 1960s is that of St Andrew's Café; Duttons furnishers once traded from here. The business was started over 100 years ago by Dick Dutton, an antiques and general dealer; it sadly closed in August 1980. We now move on to three controversial buildings in Bury. The bus station opened in April 1996 at a cost of £1.2 million, a joint collaboration with Suffolk County Council and St Edmundsbury Council. Constructed from glass and steel, this terminus has been called an alien craft among other things. The other two buildings are ghastly office blocks (the emphasis on 'block'). Triton House, where

the county and family courts sit and the driving test centre is now; and St Andrew's House, the home of the Jobcentre. There was once a reasonable-looking house here with the same name where William Chapman, tailor and outfitter, lived. Up until the First World War his shop was Nos 16–18 Buttermarket, now the Body Shop.

In medieval times this street had along its east side part of the western defences of the town, known as the Dycheweye. As a ditch with an earthen rampart it ran from Westgate to Tayfen. The slope of the former rampart can be still seen in the yard of the Bushel pub, which had stables and at one time a skittle pitch. In later years, to the side of the yard entrance on St Andrew's Street, Carman newsagents used to operate from a tin shed a Sunday newspaper round; a recent modern development All Saints Court is here now. Further up the street, in 1874 the first purpose-built flats in Bury were constructed on land given to Sarah Bott by the Quakers. Known colloquially as the 'Quaker Homes', their real name is the Fennell Homes after the miserly Quaker brother and sister Samuel and Sarah Fennell who had left money to Sarah Bott; they most certainly would not have been pleased with the philanthropic Sarah. Nearby, the public library opened up in 1983 which replaced the Cornhill library. This was converted into four shops by new owners the Southend Estates Group; in turn they then paid £1 million to build the new library, whose entrance is on the appropriately named Sergeants Walk (the former police station adjacent in St John's Street). Suffolk County Council had only to pay £11,000 for its completion; its chairman Capt. Robin Sheepshanks had laid the foundation stone in 1982. The library was refurbished in 2010 by Barnes Construction of Ipswich. A terrace of seven townhouses was built opposite by Hartog Hutton Ltd in 2000. These back on to a large forecourt where St Edmunds garage was in the 1960s; there have been various motor-associated businesses trading here since. Also nearby, from the 1960s, was Ron's Café owned by Ron Smith; it was a rendezvous point where many a misspent youth happened on the pinball and fruit machines!

Tree-lined St Andrew's Street North.

St Botolphs Lane

Called Yoxfore Lane in medieval times, the lane ran off Southgate Street until meeting St Botolph's Bridge. St Botolph was an English saint from AD 680 and was a patron saint of travellers; a medieval chapel to him was established in Southgate Street. With the nationwide suppression of the Catholic faith in later years, many were forced to worship in secret. One such place was at the rear of South Hill House, on the corner of Southgate Street and today's St Botolph's Lane. A small chapel that locked over into the lane held prohibited services here at the end of the eighteenth century. South Hill House, a fine house with internal features going back to the late fifteenth or sixteenth century, was owned by the recusant Father John Gage, a younger brother of Sir Thomas Rookwood-Gage of Hengrave. A Protestant, Madam White, was to become a subsequent tenant of the house; she would later lend her name to this thoroughfare – Madam Whites Lane.

A Victorian academy for young ladies was run here by Amelia Hitchins; an apocryphal story was that this was the Westgate School that featured in Charles Dickens's famous novel *The Pickwick Papers*, but no actual proof exists. When you enter the lane, on the left there is a large red-brick building known today as the Warehouse but built as a school for boys and run by a widow, Mrs Susan Aldridge. Pupils under ten were charged 30 guineas per annum and those over sixteen, 50 guineas. The boarders had to provide their own clothing, including at least three pairs of drawers (underpants) if worn! The building still has the school bell on its roof, and this contributed to its Grade II* listing as it is an uncommon feature. There used to be a tunnel under the lane near the bend so that pupils could have access to the exercise yard opposite. This caused major problems when the Sexton Meadows estate was being built. Services from the Haberdon were to come through the lane to it but hit the filled-in tunnel, resulting in their rerouting. After the building ceased to be a school, it became a furniture storage depot for Lands furniture removers of Churchgate Street; then it was a Pickford's repository until being turned into offices by Driver, Prior & Theobald architects in the 1980s.

Haberdon Cottage is nearby; the Haberdon area was once a manor of the abbey in the medieval period; a white bull was tethered here so barren women could stroke its flanks, hoping to get pregnant – part of a ritual finished off by praying at St Edmund's shrine. The Haberdon is now the home of Bury Rugby Club. Further along in a wall is a rather strange stone white bust; why it was put there is a mystery. You cannot leave the lane without mention of D. J. Evans; trading in East Anglia for over eighty years, they have rightfully assumed the mantle of the closed Andrew & Plumptons as the Bury treasure house of tools and fasteners, and for excellent service.

Above and below: School Bell / Flooding in 1968.

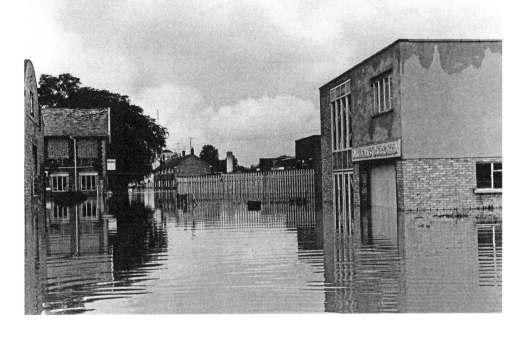

The sloping 'Bungee'.

St Edmundsbury Mews

This is a private road at the southern end of St Andrew's Street South with a small development of townhouses on what was once the site of the Golden Lion Brewery. This independent brewery was brewing beer from around 1868 until 1896. It had a bar tap at No. 57 Guildhall Street, which closed in 1907. The brewer and also landlord of the tap was Thomas Simmonds, and although he died in 1884, the brewery remained in the family until its closure. Reuben Warren then on went on to run his wheelwright business here. The weatherboarded building close to the road was at one time home to the Marsham Tyre Co. and then National Tyres during the twentieth century. At the southern end of the building was the Carlo Fish Restaurant, their fish and chips were very popular. The feature that is most prominent is the sloping forecourt from the Curry family business, West End Shoe Repairs, up to where the rear of the former British Legion Club is (now the Hunter Club as of 2016) . This was once part of the medieval western defences of the town known as the Ditchway but known by locals in the past as 'the Bungee'. How this name came about is a mystery. The brewery buildings included a red-brick chimney and a malthouse, which was more or less in use by G. B. Upholstery up to the time of demolition in 2003. The new homes follow a building line similar to what was previously there and were named St Edmundsbury Mews after the once-magnificent abbey of St Edmundsbury.

St Olave's Precinct

The name St Olave is an anglicised version of St Olaf. Olaf Haraldsson was born in AD 995 in Norway and was baptised aged nineteen at Rouen in France. He returned to his birthplace and defeated Earl Svein at the great sea battle of Nesjar. Olaf became king of Norway then set about converting his people to Christianity. He died at the Battle of Stiklesbad in 1030 and was canonised soon after, becoming the patron saint of Norway. The shopping precinct is on the Howard Estate, a large housing development built from 1960 onwards; the name Howard coming from the earls of Suffolk of that name. It was to help cater not only for an expanding Bury St Edmunds but also for the London overspill. Much-needed industry was relocated to the town from London along with their workforce and their families. An apocryphal story relating to the building of the shops concerns that of the borough clerk of works at the time, Ernie Bunkle. Construction was nearing first lift when the keen-eyed Ernie, who had checked on the colour and type of brick, noticed what was in front of him did not conform to the tender specifications. This error on the builder's part resulted in a rebuild. There is a supermarket and a mix of thirteen shops with flats above now. Peyton Plaice Fish & Chip shop has been here for forty-four years and is still run by the Devine family. A pub, the Merry Go Round, was situated at the end of the precinct with St Olave's Road. A very imaginative internal design of seated areas based on a carousel in the lounge bar made it a very popular venue for live music. It was owned by Watneys and was one of their many themed pubs across the country. It closed due to lack of investment and was later destroyed in an arson attack in 2001. A recent eight-home development by Havebury on the site received an award for 'being innovative and architecturally striking' and was officially opened in May 2011.

The Merry Go Round on fire.

Tayfen Road

As its name suggests, this was a waterlogged area; the Tay was a stream emanating from springs in the area off Spring Lane, which is no longer visible. Osier beds were once here; the young flexible willow twigs were invaluable for weaving into baskets. This was also a place of execution in days gone by. In 1834, a Hull-based company, Malam & Peckston, were contracted by the Bury Paving and Lighting commissioners to provide gas for street lighting and housing. After only a few months the firm folded, but a consortium of local business people took over, the street lighting making an amazing difference to parts of the town. On the corner with Station Hill a beerhouse opened in 1857, called the Segment after its curved shape; it would become the Ipswich Arms in 1864. After the millennium it was in need of rejuvenation and investment; it had an internal makeover and also two separate radical name changes, the Gaff and Bar Curvo. The only gaffe was giving ultra-modern names to this traditional pub. It is now back on track as the Beerhouse, with an entrepreneur-owner having a microbrewery producing real ale. Nearby, the demise of another pub, the Royal Oak, preceded the much-vaunted Bury inner relief road that was to run from Northgate roundabout to Western Way. Many properties were blighted along the way including Tayfen Terrace. With demolition looming, these Victorian cottages were saved when the road idea was scrapped; their restoration received an award in 2003. Businesses have come and gone

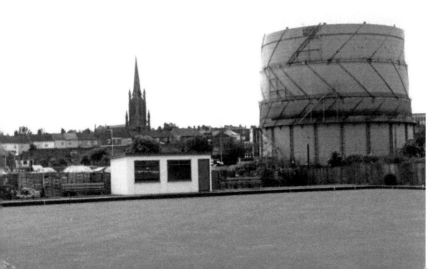

The last gasholder.

in Tayfen Road. The Gas Works with the last gasholder of three demolished in 2016, along with the Lucky Break snooker club in the old T. H. Wenn & Co. maltings, Grafton Harvey clothing factory and various garages. Vision 31, the master plan for the future development of the town, will transform Tayfen Road beyond recognition.

Thingoe Hill

Thingoe is a corruption of 'Thing-How', a Saxon term for 'Assembly Hill'. One of the eight and a half hundreds given to the abbey by Edward the Confessor, which eventually became West Suffolk, this name will always be associated with the council that was integrated into St Edmundsbury Council in 1974. Thingoe Council was in existence for eighty years and had their offices in Northgate Street from 1968 until 1974. Another link to the name is that of The Thingoe Union Workhouse that was built in 1837 in Mill Road as the second workhouse in Bury. Thingoe Hill was locally known as 'Betty Burroughs Hill' for many years after the last woman to be hanged there in 1766. Elizabeth Burroughs was convicted on flimsy evidence of the murder of Mary Booty, the housekeeper of upholsterer Henry Steward, who lived on the western side of Cornhill near the corner with Brentgovel Street. She protested her innocence to the last saying, 'Would you have me die with a lie upon my mouth; I die innocent as an unborn child.' Henry Steward was also in the dock but was acquitted, though the finger of suspicion was pointed at him for many years after. At the top of the hill there is a large development of flats and townhouses from 2008 known as Peach Maltings, several of which were purchased as buy-to-let investments. Many of these and the former Douglas Warne's clothing factory (Fitta Bodies Gym in 2016) nearby look on to part of the A14 Bury bypass, which opened in late 1973. In 2014, a cycle bridge known as the Malthouse Bridge spanning the A14

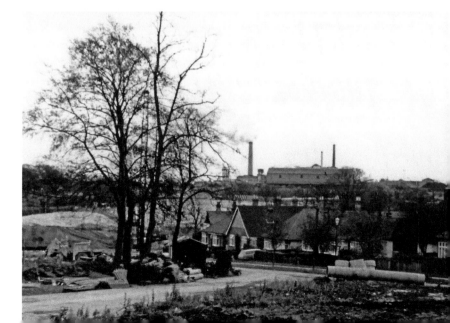

A14 under construction from Thingoe Hill.

from Thingoe Hill to Northgate Avenue was opened; funded in part by the Sustrans' charity that promotes sustainable transport.

The Vinefields

There were indeed vinefields in Bury St Edmunds off the area now known as Eastgate, providing grapes for wine from 1211. Winemaking in monasteries was important for rituals, rites and services conducted in Bury by Benedictine monks. This site for growing grapes was on a definite incline from Eastgate Street, but as this is north-west facing, the grapes must have been blessed as normally vines face south to take advantage of a sunny disposition. Maybe the climate was a lot warmer back in those times. Immediate access to these vinefields by the townspeople was by laying planks through the open buttresses of what we know today as the Abbots Bridge. During the Dissolution of the Monasteries by Henry VIII in 1539, thousands of former ecclesiastical locations were sold off. By 1560, the abbey of St Edmundsbury and the vinefields along with a couple of other sites had been sold off to John Eyer, one of the town's Guildhall Feoffees. In 1834, two brothers, Francis and Frederick Clark, both local publicans of the Globe and Coach & Horses respectively, went into the property market and built a row of six cottages on the vinefields. Unfortunately, speculation was the downfall of Francis and he died bankrupt in 1853 aged fifty-six. Frederick died in 1870 aged seventy-one. The cottages are still there today unaltered, something unusual in the town; a plaque at their southern end confirms the Clark connection. In 1883, the Bury St Edmunds Grammar School relocated from St Michaels Close in Northgate Street to purpose-built buildings on the vinefields; with the ending of the grammar schools in 1972, these became St James' Middle School. Two rows of terraced houses known as Vinefields Terrace and Pelican Court off Eastgate Street were demolished to make way for a new estate, the entrance to which was by the ancient Vinefields Lane. On the site of Vinefields Farm, twenty-three houses were built by the Direct Labour Organisation of the council, using standard building methods and sixty-six by George Wimpey & Co. Ltd, which were constructed using a very unconventional method. 'No Fines' (without sand), a 1:10 mix of cement and 20 mm aggregate, was mixed mechanically on site then pumped into formwork (shuttering) on traditional foundations, the formwork being removed after the concrete had hardened. The external walls were rendered to increase weather protection and internally were either plastered or dry-lined in some cases. These walls were up to 13 inches thick without cavities. Other houses of this type were built in and around Beeton's Way on the Howard Estate. This sort of prefabricated housing was countrywide and developed under the Ministry of works from 1947 to 1977.

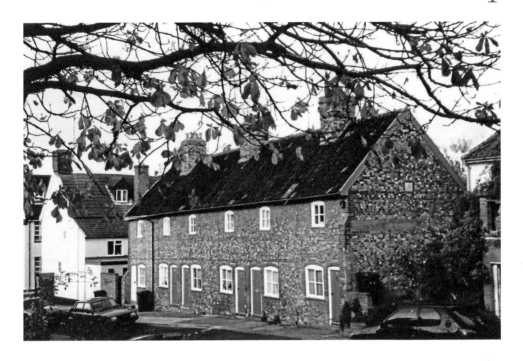

Above: The Clark cottages.
Below: 'No Fines' houses.

Unicorn Place

This small development of twenty-one, three-storey terraced townhouses was built during 1970 and is at the top of Eastgate Street. Unicorn Place is named after the former Unicorn Inn which stood on the corner with Eastgate Street. When first built it may have been a hall house but was used as a hostelry for weary travellers – the first they encountered as they entered Bury from the Norwich Road. Grade II listed, its timber-framed interior dates from the late fifteenth or early sixteenth century. According to the listing by St Edmundsbury Council, there are 'curious drawings' in red ochre on the plaster within the roof space resembling windmills. The colourful landlord of the Unicorn in 1790 was John Green, and during part of the nineteenth century it was owned by Bullards, a Norwich brewer. Clark's Brewery of Risbygate Street supplied the pub with beer from 1903 until they themselves were taken over by Greene King in 1917. However, their tenure lasted only a further seven years as it was considered for closure by the borough's licensing committee along with the Star Inn further down in Mustow Street. To the rear of the Unicorn was a bowling green used for many years by the Abbey Bowling Club; a twentieth-century extension was built here called Unicorn Cottage. The Unicorn is now a private house, the only external vestige of its former life being a small window above a filled-in barrel chute on to the Eastgate Street pavement. The houses in the Place were built on part of a pasture known as the Pightle that once belonged to the nearby Eastgate Barns Farm – a medieval grange of Bury Abbey owned by the cellarer. It was his duty as an obedentiary (officer of the abbey) to supply provisions and arrange catering for around sixty Benedictine monks who were the keepers of St Edmund's shrine until 1539. In 1867, the prestigious Royal Agricultural Show was held on meadows close by belonging to Mr Thomas Taylor.

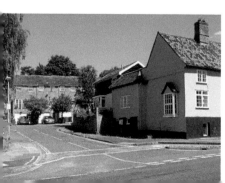

Entrance to Unicorn Place.

V

Victoria Street

The purchasing of land at the end of Field Lane from the estate of the deceased George Brown of Tostock led to the establishment of the borough cemetery. There followed further land purchases to create the Westfarm/Field Estate. An early part of this development was in Victoria Street, where Walter Neatham built Nos 50 and 51 using red brick in 1860, perhaps the first houses in the street. Nos 22 and 23 are slightly more memorable as they have the unusual name of 'Notice to Quit Cottages'. Built in 1874 on what was formerly a market garden, the owner was Charles Nunn of Sextons Hall, then part of Westley (now in Newmarket Road). Why he chose this name we can but only guess. Opposite and on the corner with Princes Street, John Palfrey started the Victoria Laundry at the beginning of the twentieth century. It passed into the ownership of R. Haylock & Sons, eventually being taken over by the Hand Laundry before closing in the 1960s. Down the street further at Nos 7 and 8, Robert Russell Baron had his initials and the date of 1873 on rear walls. He was a bank clerk and progressed to live in Northend House on Fornham Road by 1908. I often used to wonder where the road name of Russell Baron Road, Fornham St Martin, had come from. The 1950s saw Ridleys Paints move to Victoria Street from Abbeygate Street; they had acquired the Victoria Works premises of W. G. Smith & Co. Ltd, manufacturers of 'All Steel' non-conducting glasshouses. Ridleys were eventually taken over by Kent Blaxhill, who themselves later moved to Arras Road; Nevilles Close run by the Hanover Housing Association is on the site now. Perhaps the building that many people can remember though is Victoria Infant School where the Victoria Surgery is today. The school closed after 101 years in 1976. The large classroom had a big 'tortoise stove' which had a guard around; children would dry their clothes on it and in very cold weather thaw their school milk near it.

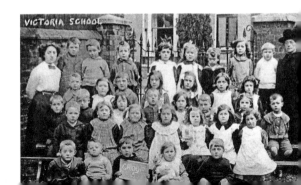

Victoria Infant School, Group 5, 1902.

Westgate Street

The town's West Gate used to stand where the ambiguous double mini roundabout is today and was pulled down in July 1765. A profit of 1s was made after the demolition materials were sold for £10 10s. Unlike the rest of the town gates, where there were chapels to Our Lady, in medieval times a hermitage was close by instead. Many years later, the shop corner with Guildhall Street was altered to accommodate traffic. There is still evidence of the ancient timber-framed building just visible to the rear of the Chinese takeaway (previously a Co-op butcher). When the corner with St Andrew's Street South was rebuilt in the twentieth century, the cottages here known as Hellfire Corner were also demolished. Another change is that of Turret Close opposite; for many years it was the home of the St Nicholas Hospice until its move to a purpose-built unit at the West Suffolk Hospital. A former owner of this Grade II* listed house was John Corsbie (see Corsbie Close). Nearby at No. 21 is the presbytery, from around 1761, of the Roman Catholic Church of St Edmund. Services were held here then by Father Gage, and only with the relaxed restrictions of Catholic involvement in public life and more freedom of worship could the church be built to designs by Charles Day of Worcester in 1837. In 2014, a complete redecoration transformed the interior for the congregation, perhaps the largest of any church in Suffolk. Numbers 17 and 18 are fine houses while at No. 19 Edmund Ward,

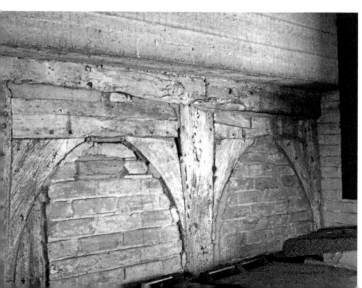

Ancient timbers.

a cork cutter, lived; his house was removed to allow access to the church site. Opposite on the corner with Whiting Street is what can only be described as a 'real pub', The Rose & Crown, complete with Jug & Bottle. Close by at No. 56 is Bernard Batt House, named after a respected surgeon of Angel Hill; once a nurse's home, it is now the YMCA.

Greene King's Westgate Brewery dominates the street; its former maltings built by Edward Greene in 1880 were successfully converted to residential use, including agreeable extensions in 2004. Part of the maltings's entrance gate, complete with metal spikes on top and postern gate, was used as the entrance to 'Bury Jail' in the celebrated television series *Lovejoy*, which ran from 1986 to 94, starring Ian McShane as the lovable rogue antique dealer. Westgate House opposite was E. Greene's home for many years with his first wife Emily, who died in 1848. In 1870, he remarried Lady Dorothea Hoste, who was the widow of Admiral Sir William Hoste; they had been renting Westgate House for a short while. Edward and his new wife went on to purchase Nether Hall, in Pakenham. The thing was, she was an inveterate snob as she continued to use her title instead of plain Mrs Greene, even though her husband of some standing was MP for Bury St Edmunds. During the twentieth century, the top floor of Westgate House was used by West Suffolk County Council Architect's Dept. Along further is one the gems of Bury St Edmunds, the Theatre Royal. Its architect, William Wilkins, had chosen this site for the 'New Theatre' due to its natural gradient; it opened in 1819. Perhaps the most famous production here was the premiere of *Charley's Aunt* in 1892 with its risqué content being tested on a provincial audience; the play was a resounding success. The theatre closed in 1925, languishing as a GK barrel store until it was restored forty years later. As the only working Regency Theatre in the country it is now run by the National Trust, thanks to the generosity of GK. Opposite the theatre is the brewery Brewhouse from 1939, alongside the GK visitors' centre; the brewery

'Lovejoy's jail gate'.

tours from here are very popular. No. 1 Westgate Street, was the home of Lot Jackaman, renowned builder of the Corn Exchange, 1861. He included several examples of his workmanship on his house. Sadly, he died just over a year after its completion in 1884.

West Road

As the boundary for many years of the Westfield Estate, it now consists of many house styles. Nos 23 and 25 were aptly named West View Cottages; built in 1884, they looked over open fields, while No. 31 was put on the market in November 1999, having been in the same family for over 100 years. West Road ran uphill from Westley Road, then ran parallel with the cemetery, meeting Hospital Road at a sharp bend at the bottom of the hill. Until it was altered, several road accidents occurred here including wartime convoys and a brick lorry that shed its load. At the junction with Abbot Road, there used to be a white farmhouse by the name of Priors Farm; it was demolished at the beginning of the 1960s to allow for an L-shaped block of flats. A major headache for the demolition crew was how to remove the brick/reinforced concrete domed air-raid shelter from the Second World War. It was solved by burning inside all the timber from the house and the inferno cracked the dome. Arguably the highest spot in town, the top of 'Cemetery Hill' became the location of the borough water tower in 1952; now it looks forlorn and unkempt, being covered with unsightly phone masts. On the corner with Westbury Avenue (once known as Priors Lane) was a Cooperative self-serve grocery store with a butcher's shop next door. They closed in 1983 after fifty years in existence, victims of larger competitors. At first a fitted kitchen company, Harmony Kitchens traded from here, then it became All Over Beauty from 1986. As of 2016, they are still here. Opposite is West Road Church, formerly West Road Hall from 1939. A Nonconformist group, the Brethren, used to meet in Garland Street but when the opportunity arose to purchase this land on the corner with Queens Road for £300, it was taken. One of three standard 'church designs' by the Mildenhall Airbase builders, John Laing, at the cost of £2,000 was selected by the church elders, Percy Lee and Albert Catton among them. During the Second World War, a canteen was run from part of the Hall. In the 1960s the hall had acquired the neighbouring No. 68 Queens Road with a link made between them. This was followed up later on with the purchase of No. 69, whose cellars were knocked through to provide a club room. However, the decision was later made to build a new church as the congregation expanded. In 1991, the last service was conducted in the hall; demolition followed, and though many building materials were reused, costs overran. However, advantageous loans were soon repaid. While works were carried out, Sunday services were carried out at King Edward VI School, and in November 1992, the newly named West Road Church came into being. The popularity of the church grew but so did its car parking problems. This was partially solved with a purchase of the adjacent garden of No. 33 West Road, which became a tarmacked car park. Today the church goes from strength to strength.

Above left: Albert Catton on the left, Percy Lee on the right.

Above right: The water tower of 1952.

Below: The Priors Inn with West Road on the left.

William Barnaby Yard

Six former almshouses on College Street are the frontage to William Barnaby Yard. They were originally for the poor and were endowed by William Barnaby, one-time steward of Hengrave Hall, in 1571. He married well – his wife was a widow, Lady Frances Fitzwarrin, daughter of Sir Thomas Kytson of Hengrave. Her first husband was John Bouchier, Lord Fitzwarrin (strangely enough, he was also her stepbrother). After Frances and William (a Saxham man) were married in 1557, they lived out at the Manor House, Great Saxham. However, when she died in 1589, she was buried in St Peter's Church in Tawstock, Devon, the home of the Bouchier family. William conveyed the almshouses to the Guildhall Feoffees in 1570. The almshouses were rebuilt by Steggles & Son in 1826, but they then fell into disrepair at the turn of the twentieth century and were used as a builder's yard and then as Marlow & Co. builder's merchants from 1925 to 1978. At one time Marlow's Yard was a throughway and could also be accessed from Churchgate Street, where they had a showroom. Marlow's was formed in 1925 when Albert Marlow got together with Edwin Underwood. Albert had worked for local timber merchants Watsons and Edwin had been associated with a major timber trading company. Starting in 1980, Mildenhall builders F. W. Cocksedge and their surveyor Charles Morris from Harling, returned them to their original function as homes and built new houses to the rear, now called William Barnaby Yard.

William Barnaby frontage.

Woolhall Street

The Clothiers Woolhall once stood here for the business of dealing in wool; another woolhall was further up the market but owned by the corporation. Bury St Edmunds had a thriving economy during medieval times, which was reliant not only on St Edmundsbury Abbey but the wool trade as well. One of the much later exponents of this was James Oakes, who had inherited a yarn-making business in St Andrews Street South from his wealthy uncle, Orbell Ray. However, with the decline of the wool industry towards the end of the eighteenth century, he successfully moved into banking. This had a knock-on effect as John Green, the owner of the deteriorating Clothiers Woolhall, was declared bankrupt in 1823. Five years later, it was decided to demolish the hall to create an access for more traffic. Until then a narrow lane had been the only means of getting into St Andrews Street and into Field Lane from Cornhill. The neighbouring Woolpack Inn eventually became Everards Hotel in 1864 when Michael Everard purchased it; his family had connections to the Suffolk Hotel. Everards sadly closed in 1987; the facade was retained, but the many architectural delights within disappeared. Clearance of the site at the rear uncovered seventeen wells, probably a vestige of when it was the short-lived Buckley and Garness brewery. At different times in recent years, large holes have suddenly appeared in the street, giving rise to that well-propounded theory that Bury St Edmunds is honeycombed with tunnels. On the opposite corner to Everards was the Bury Jail which was demolished in 1770. Many Quakers had been treated cruelly here. With the subsequent opening of the new jail in Sicklesmere Road in 1805, more humane treatment was meted out. Further up Woolhall Street on the north side was the ironmongery business of William Farrow in the 1920s.

Back of Everards.

'X'-Chequer Square

As there is no location in Bury beginning with X or bloodthirsty 'x-rated' site, this is it – Ex-Chequer Square! In medieval times this area, prone to flooding, was known as Paddock Pool. For many years it was thought that the exchequer of the abbey was also here; hence on a fifteenth-century map of Bury it is shown as Escheker. The name derives from a chequerboard used in counting and reckoning in days gone by. An exchequer was responsible for collecting revenues such as rents or taxes and paying out monies; the officer of the abbey or obedentiary to do this was a thesaurarius; we would know him today as a treasurer. However, as a place akin to a treasury, would the abbot have allowed it outside of the abbey walls beyond his watchful eye? Another idea touted is that there was a Chequers Inn here, possibly on the site of No. 4 today. What is definite is that No. 3 was home to the fifteenth-century merchant John Baret, a contemporary of Jankyn Smyth, premier medieval benefactor of Bury. In recent years, in the course of refurbishment medieval wall paintings were discovered here, along with a fourteenth-century stone archway. John inherited family wealth, which had been founded on the wool and cloth industry, and his wonderful chantry chapel ceiling and tomb can be seen in St Mary's Church. The house adjacent to his was known as the Spinners House for many years as this is where some of his workers were employed. During the Second World War, both houses were used as a Forces Study Centre operated by the British Army Educational Corps and highlighted in that delightful book *A Suffolk Summer* by John Appleby, an American serviceman. Nos 1 and 2 Chequer Square date from 1840, which we know because there was a row between the owners and Bury's paving commissioners then as to how far the splendid wrought-iron balconies were to protrude. The much-moved obelisk, with the weather-worn borough coat-of-arms, now stands forlornly amid parked cars.

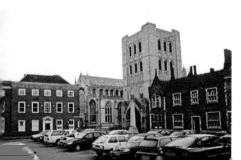

Still a car park.

Y

Yeomanry Yard

A militia barracks was built on a 2-acre site in Cemetery Road in 1857/58 to designs by an Ipswich architect R. M. Phipson. This catered for the general needs of many, consisting of married men's quarters, married sergeant's accommodation and an adjutant's house. Two armouries held sufficient weaponry for 1,000 men. There was a parade ground and even a gym; the cost to purchase the land and erect the buildings was £8,000. The building style was Tudor, the dark and light red-dressed bricks worked well together. A cannon on an iron carriage once stood at the entrance to the parade ground; it was allegedly captured as a trophy from the Russians during the Crimean War. The Militia Act of 1757 lays out that parishes had to submit a list of adult males aged eighteen to fifty to serve as a volunteer reserve force that could be called up in times of need. A three-year stint was initially served, rising to five years later on. The class system of the day led to an elite volunteer cavalry force being raised in 1794; added to the militia, they were to combat the growing threat of Napoleon. The Yeomanry, as they were generally known, came from the gentleman class and farming stock as access to mounts was vital for horses were not supplied! Some units fought in the Boer War, and in 1908 the militia was replaced by the Special Reserve, which later became the Territorial Army. The barracks were sold off after new barracks were built in Out Risbygate in 1878, though some facilities were retained. In 1916, a First World War Zeppelin sent to destroy the militia barracks and Boby's Engineering ended up bombing Chalk Road and Mill Road, and many people killed. In 1991, following intensive subterranean investigations, the parade ground was removed and built on in by R. G. Carter Builders. The flats and houses costing £1.4 million were built in a sympathetic style to the existing structures, appropriately now called Yeomanry Yard.

One way in. One way out.

Zulu Lane

This footpath is between today's Queens Road and York Road and is shown on an 1886 Ordnance Survey map. Yet it has always been called Zulu Lane – why? The houses in both roads were mainly built in the late Victorian and Edwardian eras, and given the predilection of those times to honour British heroes and battles you would have thought there would be a link close by, but there is none. However, there is a tenuous connection between Bury St Edmunds and the Zulu Wars via the village of Walsham-Le-Willows. There, local JP Hooper John Wilkinson had six sons, the youngest of whom was Thomas Edward, born in 1837. Thomas went to Bury Grammar School, a well-respected place of learning. This was evident because he went from there to King's College then on to Jesus College, Cambridge, obtaining a BA in 1859. Two years later he was an ordained curate of St Mary's Church, Cavendish. His next appointment was as a vicar in Rickinghall, followed by an amazing career move as inaugural bishop of Zululand in southern Africa in 1870. His full title was Bishop for the Zulus and the tribes towards the Zambesi. The battles of Isandlwana, Rorke's Drift and finally Ulindi in 1879 saw much of his diocese torched to the ground and must have influenced him to return home to be rector of Caerhays, Cornwall, from 1879 to 1884. Thomas Wilkinson's last elevated position was as the Anglican bishop

No cars up here please!

of north and central Europe from 1886 until 1911. He was a prolific writer; one of his books was *A Suffolk Boy in East Africa*; Wilkinson died in Khartoum in 1914. So there it is: a Zulu connection! Local councillor David Nettleton was instrumental in having the lane's name adopted with signage. Both he and I are of the opinion that Zulu Lane is of an age and *did* precede that wonderful British stiff-upper-lip film, *Zulu* (1964), starring Michael Caine.

Map of Bury St Edmunds, *c.* 1960.

Also available from Amberley Publishing

Bury St Edmunds
Memories

MARTYN TAYLOR

978 1 4456 4497 4

To order direct please call 01453 847 800
or visit www.amberely-books.com